PFT

AN INTRODUCTION TO
MIXED MEDIA

The DK Art School

AN INTRODUCTION TO
MIXED MEDIA

MICHAEL WRIGHT

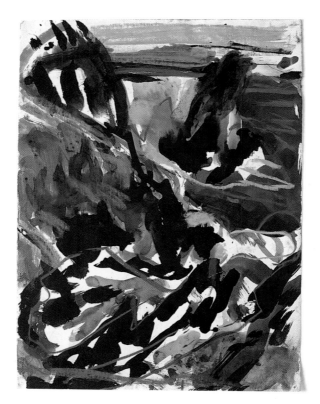

DORLING KINDERSLEY
LONDON • NEW YORK • STUTTGART
IN ASSOCIATION WITH THE ROYAL ACADEMY OF ARTS

A DORLING KINDERSLEY BOOK

Art editor Tassy King
Project editor Joanna Warwick
Assistant editor Neil Lockley
Design assistant Stephen Croucher
Senior editor Gwen Edmonds
Senior art editor Claire Legemah
Managing editor Sean Moore
Managing art editor Toni Kay
Production controller Helen Creeke
Photography Steve Gorton
Picture research Jo Walton

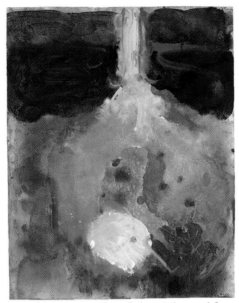

To the memory of my father, John, and for
the unfailing support of my mother, Mary,
and uncle Michael, who have encouraged
my artistic endeavours since early childhood.

This DK Art School/Art book
first published in Great Britain in 1995
by Dorling Kindersley Limited,
9 Henrietta Street, London WC2E 8PS

Copyright © 1995

Dorling Kindersley Limited, London

ISBN 0751 301 779

Colour reproduction by Colourscan in Singapore

Printed and bound in Singapore by Toppan

CONTENTS

Introduction 6
A Brief History 8
Compatible Supports 12
Drawing Materials 14
Painting Materials 16
Charcoal and Black Ink 18
Charcoal and Pastels 20
Line and Colour 22
Resist Techniques 24
Gallery of Drawing 26
Multilayered Compositions 28
Oil and Soft Pastels 30
Experimenting with Surface 32
Adding Texture 34
Gesso and Wax 36
Unusual Materials 38
Gallery of Painting 40
Collage Materials 42
Printing Materials 44
Colour Collage 46
Photo-collaging 48
Handmade Paper 50
Creating an Image in Paper 52
Collage, Laminate and Frottage 54
Low Reliefs 56
Gallery of Collage 58
Block Printmaking 60
Monoprint 62
Collagraph Printing 64
Gallery of Monoprint 66
Preserving and Storing 68
Glossary 70
Index/Acknowledgements 72

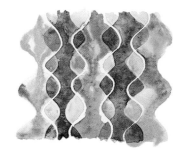

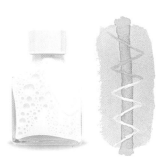

MIXED MEDIA

THE TERM "MIXED MEDIA" is commonly used to define works of art which combine different painting and drawing media. It is an exciting and experimental working practice which allows for the combination of likely and unlikely media. As a result it has enabled the extension of drawing and painting techniques into areas of photography, printmaking, collage, and low relief construction. Combining different media has become a consistent feature of contemporary practice and it is rare to see a group exhibition now in which there is not some use of mixed media. Most visual arts courses encourage students to focus on the use of mixed media to develop a more imaginative approach to image making and to learn more about materials. Mixing your media is an excellent way to revitalize your awareness of a familiar medium and to establish new and imaginative interpretations on familiar themes.

Charcoal, pastel and ink

These are mixed media studies in which the artist has combined drawing media with collage materials.

Combining your materials

When developing a watercolour it is usual to lightly sketch in pencil, then work the image in watercolour washes and finally finish by adding highlights in an opaque gouache medium. Similarly, when creating a pastel painting charcoal is often used to establish the basic drawing which is then overworked in pastel. The development of mixed media as technique has been encouraged by the relaxed attitude to experimentation which has arisen in this century. The advent of new art materials, such as acrylics, and the development of new creative techniques in collage, print and photographic processes has seen an increase in mixed media works in all the visual arts, not just in painting, but in

This striking tonal composition was developed using a wax resist technique. Warm liquid wax was applied to mask areas of the paper and to resist the ink.

Here a similar technique is used with the wax painted in vertical bands down a sheet of paper. Black ink was then brushed across the surface.

graphics, illustration and textiles. Looking at the breadth of materials used in combination this century it is exciting to realize that the expressive range of media for mixing appears to be inexhaustible. The beauty and success of many mixed media works is due to the artist's capacity for combining different medias within an aesthetically pleasing composition and in the hands of an experienced artist mundane materials such as newsprint, sandpaper and wax crayons become vehicles of eloquent expression.

A composition based on arches has been constructed using collage. Sheets of coloured tissue paper have been cut and laminated between layers of diluted PVA glue and the colours optically mixed to create new colours.

Getting started

Most of the effects and methods which will be described in the coming pages are unique to mixed media. You will be encouraged to exploit the particular qualities of different media by using them in new contexts of either juxtaposition or layering. You will be guided through the basic principles of drawing, painting, collaging and printing using the usual range of materials carried by most art shops, alongside materials found in the home and, finally, to experiment with less common materials and techniques.

This print was developed using a monotype process. Corrugated paper was used to print the brown strips, which have been laminated between sheets of tissue paper.

A collage of found and cut wooden shapes has been painted using a combination of painting techniques.

A BRIEF HISTORY

MIXED MEDIA IS USUALLY REGARDED as an art form peculiar to the 20th century but throughout the history of painting works have been produced which have successfully combined a range of the usual and more unlikely materials. There are also particular phases in Western art when mixed media works were created by using materials such as gold leaf in combination with other drawing and painting media.

FROM EARLIEST TIMES artists have created mixed media compositions by combining materials such as charcoal with earth colours and extracted minerals such as oxides or vegetable dyes. The preparation of the ground, which is the surface to which the pigment is applied, has also led to a great deal of experimentation with materials. Artists have worked on wood, vellum, and various natural fibres which have been pressed or woven into papers and textiles and also on glass and metals such as copperplate or gold leaf.

Illuminated manuscripts and icons

Early Italian church paintings are prime examples of the beauty of combining media by using a method of underpainting and combining the quality of luminous pigments with areas of gold leaf. The splendour of the gold leaf was often heightened by a technique of embossing the gesso ground, burnishing the gold leaf and occasionally by the addition of precious gems. These works were created using the richest materials available and aimed to transport the viewer from the temporal world into a state of meditation on the nature of the divine. During the 16th century artists used a warm earth colour, sanguine, (a deep blood red) with additional highlights in white chalk on coloured paper, to evoke the skin

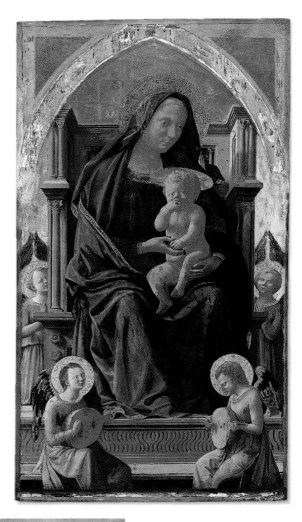

Tomasso Masaccio,
***Virgin and Child,* 1426,**
135 x 75 cm (53 x 29½ in)
Masaccio (1401–28) made a remarkable contribution to the development of Western art through the assimilation of perspective within the picture space of his compositions. The charm of this painting resides in a unique combination of treatment and materials. The use of the paint to create a naturalistic illusion of form contrasts with the abstract symbolism, and hierachical arrangement of the figures and the use of gold leaf in the halos.

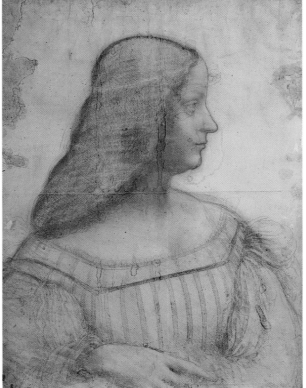

Leornado Da Vinci,
***Isabella d'Este,* 1500**
63 x 46 cm (25 x 18 in)
Leonardo da Vinci (1452–1519) was the archetypal Renaissance man who experimented with new approaches and materials. Leonardo was also instrumental in developing the practice of combining pastel with other drawing media. The term pastel is derived from the word "pasta" which means paste, and refers to the method of manufacture where pure pigment and chalks are mixed into a paste with a binding solution of gum and allowed to dry into crayons. In this eloquent profile of Isabella d'Este the work has been developed in black chalk and additional highlights are visible in the use of a yellow pastel to add colour to the neck line of the dress.

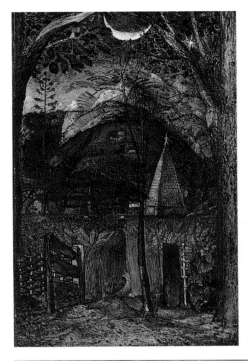

tones of the figure; creating warm and cool sensations of light and shadow. In 17th century Holland it became fashionable to heighten drawings, mainly of landscape scenes, with a limited range of tones, using yellow, brown, rose madder, green and blue watercolours. The mixed media technique of creating tinted drawings, was further developed in Britain by a number of major artists, including Turner (1775–1851),

Samuel Palmer, *A Hilly Scene,* 1826,
20.5 x 13.5 cm (8 x 5¼ in)
In this visionary evocation of an idealized rustic scene Palmer (1805–81) has loaded the painting with symbolism. Pigments mixed with gum arabic create varying areas of luminous washes and opaque colour adds to the substance of the linear drawing in pen and ink.

who lifted watercolour from the status of minor studies to complete compositions on paper, accepted as works in their own right. Two other major British artists, William Blake (1757–1827) and his pupil Samuel Palmer experimented with watercolour in combination with other media to create innovative mixed media works. Blake applied coloured washes to his prints and along with Palmer, combined watercolour with tempera and gum to build up complex surfaces combining pen and ink with transparent and opaque layers of watercolour.

Nineteenth century artists

An outstanding 19th-century exponent of mixed media techniques was Edgar Degas who combined pastel with charcoal, distemper and monotype printing techniques. Degas deliberately exploited visual tension by contrasting the varying surface qualities of the mixed media.

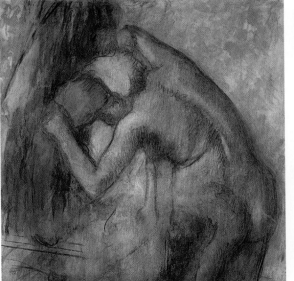

Edgar Degas, *Woman Arranging Her Hair,* 1895-1900,
77 x 75 cm (30½ x 29½ in)
Towards the end of his long career and with the failing of his eye sight Degas worked increasingly in pastels and combined his pastel with charcoal, distemper paint and monotype printing inks. He was preoccupied with the subject of the body in motion and would develop a tonal composition in charcoal which he overlaid with pastels.

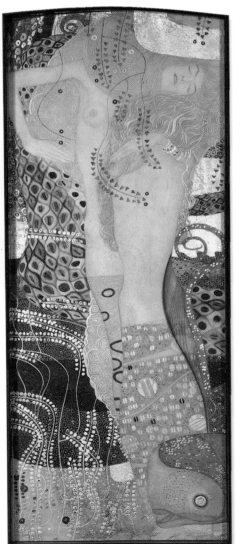

Gustav Klimt, *Watersnakes,* 1904–07,
50 x 20 cm (19¾ x 8 in)
Early devotional works which combined paint and gold leaf inspired Klimt to an utterly secular exploration of these mixed medias. He combines the sinuous movements and sensuous forms of the body with dreamlike stylized arrangements of rythmical patterns of embossed gold leaf and gold paint.

Adding colour

There are many examples of artists who add colour in a transparent or opaque form using either water-colour or gouache to linear drawings. The sculptor August Rodin, and the painters Vincent Van Gogh, Gustav Klimt and Egon Schiele were all skilled exponents of mixed media techniques. The work of Klimt emerged out of the stylistic development of Art Nouveau and many combine oil paint with gold leaf in a technique that is redolent of the religious works of previous centuries.

THE DEVELOPMENT OF the visual arts during the 20th-century has been characterized by an extraordinary diversification of approaches to both the concepts and materials of art. Two of the major protagonists of change were Georges Braque (1882–1963) and Pablo Picasso (1881–1973) who developed the use of collage by incorporating ready-made materials, such as newsprint and wallpaper, into the surface of drawing and painting compositions. The use of collage compounded a fundamental shift in awareness already developed through experiments with cubist composition, and asserted that the essence of a painting was in the independent arrangement of the surface shapes and textures rather than in the creation of an illusionistic view. This new development coincided with the political and social upheaval of the First World War which stimulated a reaction against the established order. In the visual arts this reaction manifested itself in the absurd work of the Dada movement which was then further developed by the Surrealists. Artists such as Max Ernst (1891–1976) and Joan Miro (1893–1983) exploited the techniques of mixed media and montage by juxtaposing incongruous images in disturbing and provocative arrangements that explored the unconscious and evoked an interior world of dreams and nightmares.

The dominant figure of this century is Pablo Picasso who exploited an extraordinary range of materials during his long career. He proved that any material could be transformed into art by placing familiar materials, as diverse as

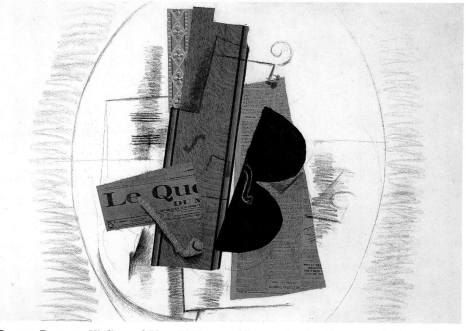

George Braque, *Violin and Pipe,* 1913
75 x 101 cm (29¼ x 39¾ in)
George Braque first considered the use of ready-made papers as an addition to his still life drawings in 1912. Braque was the son of a house painter and knew how to create decorative paint effects, such as marbling and false wood grain. *He later used this experience by incorporating these techniques along with wallpaper in his paintings. In this composition the combination of collage and charcoal simultaneously emphasizes the picture surface while suggesting space through the overlapping of different media.*

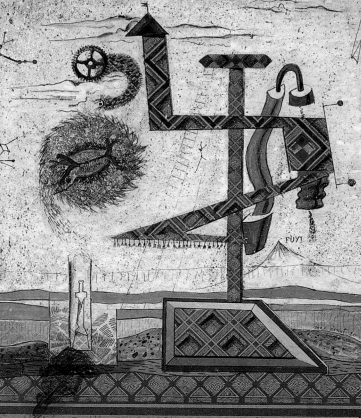

Max Ernst, *Katarina Ondulata,* 1920,
31 x 27 cm (12¼ x 10½ in)
Max Ernst's early training was in philosophy and his work as an artist can be viewed as a visual exploration of the hidden processes of the mind. Individual compositions explore the way the mind filters and retains the memory of experiences by organising shapes and textures which act as prompts to the imagination. In the lower section of the composition a strip of wallpaper has been collaged in juxtaposition with painted areas to evoke layers of geological strata. The surface of the upper section has been spattered with ink and lines drawn to suggest distant mountains and clouds

Paul Klee,
***The Magic Garden,* 1926,**
50 x 42 cm (19¾ x 16½ in)
*Paul Klee was a master of textural
control who experimented with
materials and applied a diversity
of techniques to create jewel-like
surfaces. In his hands mundane
materials transcend their original
form and turn into new creative
combinations of texture and colour
that evoke an imaginative reverie
of fantasies. Here he has used
a wire mesh mounted on a wooden
panel as a support for an application
of plaster that has then been
inscribed with patterns and stylized
images which float in the picture
space. The surface has been stained
with washes of colour which are
punctuated by opaque areas
of impasto oil paint.*

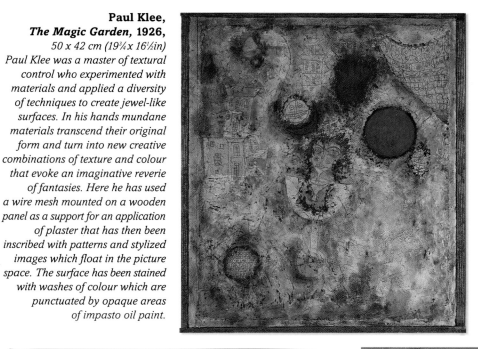

bicycle saddles in a new context.
His treatment of both materials and
techniques set a precedent for a level
of pictorial invention for all artists
in this century. Technological
innovations have also provided
new printing, photographic and
construction processes as well as the
development of new materials, such
as acrylics, which have extended the
range of pictorial effects available
to artists. In the latter half of this
century abstract and Pop artists
such as Robert Rauschenberg have
exploited mass media processes and
combined photography and found
materials within their artworks.

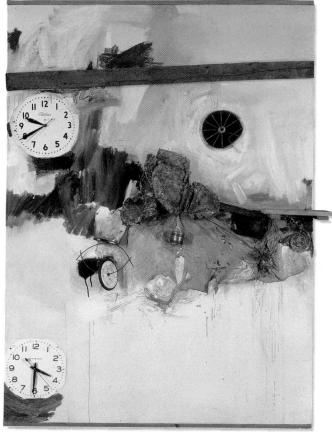

Robert Rauschenberg, *Reservoir,* 1961,
234 x 157 cm (85½ x 62½ in)
*Rauschenberg, along with other artists who were affiliated to the Pop Art
movement, chose to utilize mass media imagery in combination with
found objects and traditional painting media. The relationship between
the choice of found objects and the imagery does not work in the manner
of a meaningful narrative but as an irrational montage held together
as an abstract arrangement through the compositional skills of the artist.*

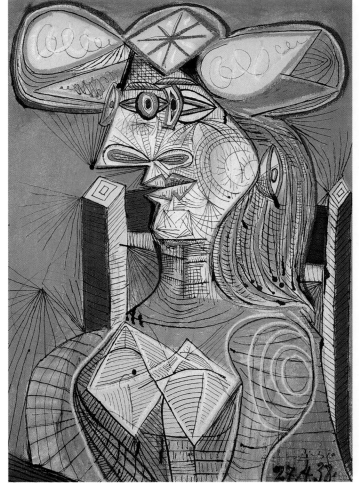

Pablo Picasso, *Seated Woman,* 1938, *76.5 x 55 cm (30 x 21½ in)*
*This composition has been energised by an insistent rhythmical line
in pen and ink which gives the forms volume and creates contrasting
areas of patterning across the surface of the work. Pastel has been
used to create large areas of colour which add luminosity to the figure.*

COMPATIBLE SUPPORTS

THE SURFACE YOU CHOOSE to work on is called the support, and its texture, colour and absorbency will influence the techniques you use to develop a mixed media composition. There is a huge selection of supports for you to explore in combination with mixed media. Try a selection of ready-made supports first and note the different ways your chosen media interact with the support. You can then experiment with creating your own supports through a simple process of "priming" and by adding a variety of textures and colours to the surface of your support.

Primed and unprimed canvas
There are two types of canvas available in various weights and widths: artist's linen, made from flax, and cotton duck. You can purchase pre-primed canvasses or prepare your own.

Commercially prepared boards
"Art boards" which have been prepared with either a surface of artists' quality paper or fine textured linen canvas, are suitable for both wet and dry techniques using media such as water-colour and pastel. Pre-coloured art board has a stiff surface and does not buckle when wet. Oil board is primed as a surface for oil and acrylic paint.

Choosing the right support

There are a few simple rules to follow to guarantee the life of a mixed media work. Dry drawing media such as charcoal, chalks and pastels need a support with sufficient tooth to hold the particles of pigment in the surface. Paper, card and linen supports have a distinct tooth which is ideal for dry media. For this reason, shiny and very smooth surfaces, such as hot pressed paper, are less suitable for extensive working in dry media.

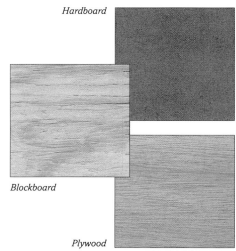

Suitable wood
The most commonly used wood supports for mixed media works are hardboard, plywood and blockboard. These are made from compressed wood dust or layers of wood which are bonded by glue. Wood panels are the most suitable supports for building low relief surfaces.

Suitable paper grounds
There are now a huge variety of papers available which are suitable for mixed media compositions. These range from artists' quality paper to hand-made coloured papers and card. The artists' quality papers are more expensive but are able to sustain prolonged applications and have a guaranteed longevity.
These papers are available in various thicknesses, weights and textures and are made from 100% cotton rag which does not become brittle and yellow with age. The three standard grades of surface for watercolour papers are, Hot-pressed (smooth), NOT (Cold-pressed, semi-rough) and Rough.

Water and oil-based media

The main criteria to bear in mind when choosing a support is whether it is suitable for wet or dry media. Water-based media require a support of sufficient absorbency to hold the liquid but not so absorbent that the colour sinks and loses its brilliance. For this reason manufacturers add size to paper to reduce its absorbency. Water-based media will cause a support to buckle as the surface absorbs the water, so the thicker the paper you choose the less dramatic the buckling will be and the more capable it will be of weathering heavy treatment.

When working with oil-based media it is generally recommended that you prepare the surface of your support with an acrylic primer because the oil will damage the surface of unprimed paper, board or canvas. Priming also reduces the absorbency of the support and stops acrylics and oil-based media from sinking into the surface and losing brilliance. A coloured support will interact with overlaid pigments and when combined with a textured surface will result in an attractive broken colour effect on the surface of the paper or canvas.

Hand and commercially-made papers

There is the most amazing range of coloured and textured papers for you to explore, available from art shops and paper specialists in single sheets, pads and rolls, An increasingly diverse selection of papers are now being made which incorporate various plant fibres such as flax, onion skin, and bracken. These papers make highly attractive and surprising supports for mixed media work and are used to create a dominant texture in a collage or print work.

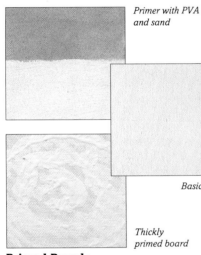

Primer with PVA and sand

Basic primer

Thickly primed board

Gesso

When applied to a surface, acrylic gesso can be manipulated to create a range of textures that can make the basic support more interesting.

Primed Boards

To create a luminous background, boards need to be primed with a suitable primer, such as acrylic primer or gesso, before applying paint. Boards can also be primed with coloured gessos made by adding acrylic paint, or can be primed with PVA and sand to create texture.

Sandpaper

You can buy sand-papers or make your own rough surfaces by mixing sand into, or sprinkling sand on top of, the gesso.

Using gesso with additives

Various materials can be added to gesso to create an exciting textured or coloured surface in low relief. Sand, string, dried grasses and pulses will all create interesting surfaces. Alternatively you can add sawdust, stone dust or any other inert powdered material to PVA glue, acrylic primer or gesso to create an interesting diversity of textures to work on. By adding a water-based paint or dried pigment, such as charcoal dust or crushed chalk pastel, you can tint the primer to any colour. You can apply the additional materials in several ways: by sprinkling or embedding them in the wet surface of the gesso so that the colour and tone of the materials remains evident, or by mixing the materials into the gesso so that they become the colour of the gesso.

DRAWING MATERIALS

T HERE ARE A WEALTH OF DRAWING MATERIALS which are suitable for mixed media and they can be used in almost any combination. Each drawing medium will produce a range of marks of a different density, tone and texture and so it is a good idea to explore the scope of line and tone that each media produces, before you experiment with them in combination. It is also important to find sympathetic combinations of drawing media that will enhance rather than detract from each other. Drawing media which are alike, such as charcoal and chalks, will work unobtrusively together whilst media with disimilar qualities, such as wax crayons and inks, will create dramatic qualities of contrast. This is because the water and the wax resist each other and create distinctive patterns.

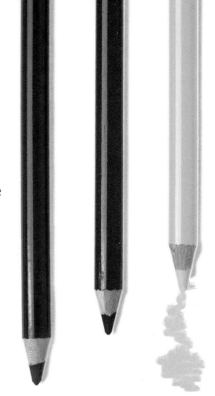

DRAWING MEDIA can be categorized into those that share similar characteristics, such as watercolour and ink, which are wet drawing media, or those that use a common method of application, such as pastels and chalks. Dry media are those which can be applied without a brush including charcoal, pastels and crayons. Wet drawing media are those which are either suspended in a liquid medium or require diluting before use.

Coloured charcoal pencils
Coloured charcoal pencils are the same as pastel crayons only slightly harder and encased in wood. Their chalky constitution makes them more suitable for subtle blending techniques and ideal for very fine detailed work.

Felt tip pens
Felt tip pens are a relatively recent addition to the repertoire of drawing materials. They produce a restricted range of marks but are popular for techniques which require a bold line and strong saturation of colour.

Sharpening
Hard pastels and charcoal can be sharpened using a pencil sharpener or sharp blade to gently pare the end to a point.

Pencil sharpener and blades

Graphite pencil

Kneadable putty rubber

Putty rubbers
Putty rubbers are suitable for erasing a range of dry drawing medias as they can be pulled and kneaded into a fine point for detailed work. You can effectively use this type of rubber as a drawing tool creating highlights in a work as you remove the pigment and reveal the surface of the support below.

Water-soluble pencils
Water-soluble pencils are used in the same manner as other pencils to create a linear drawing and areas of shading. The drawing is then washed over with a wet brush. This transforms the linear marks by dispersing the colour to create a wash drawing. Rich colour effects can also be achieved by drawing onto a damp surface to disperse the pigment.

Wax crayons

Wax crayons are popular for using in a resist technique where a drawing is first developed in wax crayon and then over-worked with a wash of watercolour or ink. The wax repells the water-based medium and shows through the layer in striking contrast. They can also be overlaid on top of each other and scratched off to reveal the layer below.

Fixatives

The surface of a mixed media work which incorporates dry media like charcoal and pastel is easily spoilt by smudging. You can avoid this by giving the work a light spray of fixative to fix the particles of pigment to the paper. Fixative is also used to build up a work in layers of different dry pigments by spraying and fixing each successive layer of colour. The fixative will alter the work by slightly darkening some of the tones. With pastel work it is very important not to over-spray as this will destroy the inherent "bloom" of the pastels. For this reason some artists do not fix the last layer, or alternatively only spray the back of the work with fixative.

Willow charcoal and charcoal pencil

Charcoal is carbonated wood which comes in various thicknesses. Paper will readily accept charcoal and it is easy to erase and alter. Charcoal can be pared and filed to a point by a blade or by rubbing its edge on glass paper. Charcoal also comes in stick and pencil form and this compressed charcoal produces a dense, velvet black.

Types of charcoal

Reed pen

Technical pen

Pen and ink

There are a wide selection of inks available; the main types are the water and shellac-based inks. Shellac -based inks are waterproof when dry and are suitable for techniques of overpainting when you do not want the ink line to spread and bleed into subsequent washes of colour. Inks also come in a full range of colours from black to the full spectrum of luminous primaries and secondaries. Inks can be worked with different tools including nib pens, reed pens and either sable, hog or synthetic brushes. A particular advantage of inks is their ability to be worked in dilutions of water, making it possible to produce monochrome works in a subtle gradation of tones. Chinese inks are sold in either sticks or bottles, and the ink can be diluted with water in a small stone well. The art of using a Chinese brush is to hold the brush vertically or diagonally so that you can vary the thickness of the line, from a delicate trace using the tip, to a full broad stroke using the heel of the brush.

Chinese block ink

Soft pastels

Soft pastels and Conté sticks

Soft pastels are essentially pure pigment held lightly in a gum solution. The soft-grained texture produced is ideal for painting because of its ease of application and blending qualities. Conté crayons are basically harder pastels with a denser texture and they are ideal for detailed work. Both types of pastel are available in a huge range of colours.

Coloured Conté sticks

Basic pen and ink

Chinese brushes

PAINTING MATERIALS

Every painting medium has particular qualities of texture and colour and all are suitable for mixed media techniques. Painting media can be divided broadly into water-based and oil-based. Water-based media include watercolours, gouache, tempera, poster colours and acrylics. Oil-based colours include oil paint, oil bars, pastels, and wax encaustic which is thinned using turpentine or white spirits. Media which share similar qualities such as watercolour and gouache are readily used in any combination whereas mixing oil and water based paints requires more careful consideration.

Oil bars
Oil bars are applied in the manner of an oil pastel, by rubbing the medium into the support. They can be further diluted on the support using a brush and turpentine.

Crushed chalk pastels

Fine hog hair oil brush (size 10)

Fine hog hair oil brush (size 12)

Brushes and palettes
Oil paint can be worked on either a hand-held palette or on a smooth impermeable sheet of board or glass. There is a specialist palette for acrylics which is a tray which keeps the paints moist to prolong mixing time. Both oils and acrylic paints can be worked using a range of brushes.

ALL PAINTS ARE MADE from coloured pigments suspended in a medium which allows the pigment to be controlled in a fluid state and to dry to form a durable surface. Each type of paint has a distinct quality of handling and will have an advantage over other painting media for certain techniques. The advantage of water-based paints is that they generally dry quickly, allowing for speed of application and ease of alteration. The acacia gum used in watercolour and gouache paints allows you to over-paint in layers without picking up the dried underlying colour. The gum also allows you to make alterations by simply wetting and lifting the colour from the support

using a sponge or tissue. Acrylic paints are also water soluble but unlike watercolour they dry to an insoluble plastic film. Acrylics can be used in transparent washes but they are also suitable for using in impasto to add texture. Manufacturers have developed a range of additives which you can add to alter the paint or retard the drying time to allow for

Palette knives and scrapers
Palette knives are used for mixing paint on a palette and painting knives are similar but specifically shaped and angled to apply the paint to the support. Scrapers are used to drag and scrape paint across the surface of a wide support and can be used to create linear patterns.

Alizarin Crimson (oil)

Cadmium Yellow (oil)

Phthalo Blue (oil)

Phthalo Green (acrylic)

Titanium White (acrylic)

Ultramarine Blue (acrylic)

Painting knife and scrapers

more controlled blending of colours. All waterbased media are suitable for overworking in different drawing media and oil-based media.

Oil paints

Oil paint is a popular medium because of its ease of manipulation and combined with its scope of colour and texture it generally surpasses water-based media. Oil paint dries slowly and is most commonly used in the "a la prima" technique of painting wet into wet. When used in a wash (or impasto) oil paint is suitable for receiving oil pastels and oil bars but will repel water-based media. It is very important to use artists' quality paints where possible as the pigments used in the paints have been tested and are known to be of a highly durable nature.

Watercolour brushes: mixed sable size 12 and 8

Gamboge

Windsor Green

Tortillons

Resist technique

The simplest way to create a resist technique is to apply an application of an oil based medium such as wax crayon, chinagraph pencil or oil pastel to a composition. These media repel water and show through the subsequent watercolour wash. Another excellent resist medium is masking fluid which can be used to create subtle colour variations.

Masking fluid

Watercolour

Watercolours are made of pigment suspended in gum solution and have different degrees of lightfastness depending on the type of pigment. Watercolours can be built up in layers of transparent washes and can also be lifted from the support by wetting and wiping away with a sponge.

Cerulean Blue

Scarlet Lake

Sponge rollers

Rollers are useful for applying liquid paint to a support. You can use small foam rollers which are suitable for watercolour, or decorators rollers for larger works in acrylics and oils. Rollers can either amplify or unify the texture of a support.

Sponges and tortillons

Sponges are used for lifting water from the surface but can also be used for applying paint. Tortillons can be used to blend in fine details in pastel works.

Natural sponge

Coarse sponge

Roller

Oil pastels

Oil pastel is bound by oil and provides a rich depth of tone and a distinct degree of transparency. Oil pastels are not readily displaced and as a consequence do not require the use of fixative. They can be worked in impasto and also diluted with spirits and moved around on the support as a wash of colour.

CHARCOAL AND BLACK INK

CHARCOAL AND BLACK INK are two tonal drawing media whose contrasting qualities of wet and dry create exciting mixed media combinations. The dry nature of charcoal produces a delightful range of tones and marks, from feint, delicate traces, through scumbled broken applications to a rich velvet black. The density of ink can be altered by adding water and can be applied with a range of tools, from sable and Chinese brushes, to reed and metal nib pens. Using these two media together you will have the freedom to exploit drawing to its optimum tonal range.

Texture and pattern

This drawing demonstrates the contrasting qualities of charcoal and ink and the expressive range of marks that both media can produce. There is a contrived tension in the composition achieved by the close arrangement of the foreground figures and the dramatic shift in scale to the figures in the background absorbed in domestic labour. The artist has used various techniques to emphasize the textures and features of the women's clothing. In contrast with the subtle areas of tone created by the charcoal, the artist has blocked in the dense area of black using a brush and ink in the jumper of the right-hand figure.

Frottage

Frottage is the technique of using the side or blunt end of a stick of charcoal, crayon or graphite to take a rubbing off a textured surface. This shows the texture of the wooden grain of a drawing board but you can also take rubbings from stone and artificial materials.

By drawing charcoal across the paper around the woman's collar, the artist has utilized the grain of the paper to amplify the texture of the support, giving the clothing a realistic appearance.

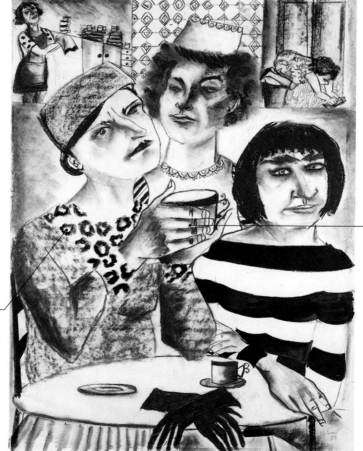

Hilary Rosen, *Cafe,* **1989, charcoal and ink**

Ink and charcoal

Ink and charcoal react in contrasting ways with the paper support. Whereas the charcoal is effectively filed away by the tooth of the paper, creating a grainy texture, the ink soaks into the surface of the paper. This absorption produces a wet effect known as bleeding, where the ink disperses across the paper surface.

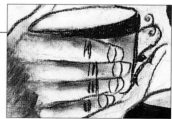

The hand and cup have a clearly defined contour with the fingers created by variations in light and shade and outlined in ink. The artist has blended the charcoal into the paper using her fingers, creating areas of depth and lighter touches.

Contrasting effects

The abstract image below also concentrates on the creative possibilities of line and tone. Two contrasting qualities of tone are created by using similar media with diffferent methods of application. The ink is applied with a brush to contrast with areas of tone created by the use of spray paint. This composition evokes organic growth through the recurrent use of cellular shapes rather than describing any specific plant form. The artist has created an ambiguously witty play of lines and patterns that draws the viewer into translating this abstract arrangement.

In the construction of this imaginative work the flow of the rhythmical marks is uninterrupted by any hesitation or correction creating an air of confident improvisation. Looking carefully into the compostion you can see the way the artist has developed complex relationships between the shapes. Some are enclosed cells, others are open, some contain nuclei and others appear to be gyrating, bending or splitting. Each delineated shape has its own unique character while maintaining a general resemblance to the other shapes.

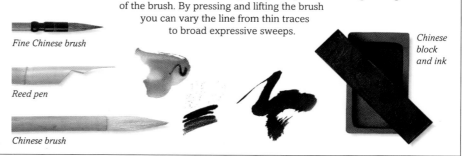

CHINESE INK

Chinese ink is a very expressive medium which requires disciplined control. The great Chinese masters of this medium would first study their subject for long periods of time until they understood its form. Working on a roll of rice paper, they would lay on diluted washes and marks in undiluted black. The art of controlling a Chinese brush is to vary the angle of the brush to the support, holding the brush vertically using the tip and at an angle using the heel of the brush. By pressing and lifting the brush you can vary the line from thin traces to broad expressive sweeps.

Fine Chinese brush

Reed pen

Chinese brush

Chinese block and ink

The linen texture of the support creates a broken line as the ink is drawn across the absorbent surface.

Marks retain the echo of the action that created them and in this example the quality of the line reflects an angular wrist action. This is in direct contrast with the diffuse and erratic character of the spray paint.

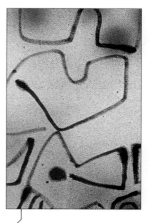

USING A DIFFUSER

A spray diffuser is used by holding the two tubes at right angles to each other and immersing the end of the longer tube in the paint. Holding the shorter end, with the plastic mouthpiece between your lips, blow firmly and your breath will draw the fluid up the longer tube and atomise the liquid into a fine spray. You can vary the spray you produce by altering the pressure of your breath and the distance and angle at which you hold the diffuser from the support.

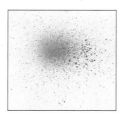

Hold the spray in a single stationary position to create a star-like explosion of ink or sweep the diffuser across the page to give a wider and finer coverage.

Wendy Pasmore, RA, *Untitled*, 1991, spray paint and ink

Visual invention

In contrast with the complexity of the shapes defined by the ink lines, a unifying tone has been created using spray paint. The beauty of this work lies in the clarity and simplicity of its construction which echoes the principles of Chinese painting. Artworks such as this do not copy, but simply evoke, the energy of nature in just the same way that the rhythm and structure of music evoke the natural harmonies and movements of the elements.

CHARCOAL AND PASTELS

CHARCOAL IS A HIGHLY VERSATILE drawing medium and its inert nature makes it highly suitable for laying down a drawing design before over-painting in a water or oil-based medium. As a tonal drawing medium, charcoal is commonly overworked with additional dry colouring media such as chalks and pastels. Aesthetically, charcoal and pastel work well together and by using the two media you can achieve subtle traces of line, delicate transitions of blended tone and dense applications of bold marks. A considerable advantage of these media is that they are easily erased and manipulated which allows for great freedom of compositional movement. Because of this it is necessary to preserve your work carefully by fixing the surface with a light spray of fixative (see p.15).

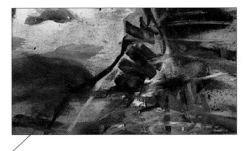

Pastel and charcoal
The responsive nature of these media encourages a sensitivity of touch and subtlety of manipulation. You can work pastel and charcoal as either line or as areas of tone by altering their angle to the support, and by working with either the edge or the side of the media.

Pigments
Both charcoal and pastel are capable of an exciting array of marks, depending on the action of the hand and how much pressure is applied. With all dry drawing media it is the raised tooth of the support which files away the particles of pigment so the harder you press the more pigment is deposited on the surface.

A very open pattern of marks created in a limited colour range has been used to define the rocks and sky. The artist has blocked in areas with black ink and charcoal and then covered the area in pastel, to suggest the rock strata.

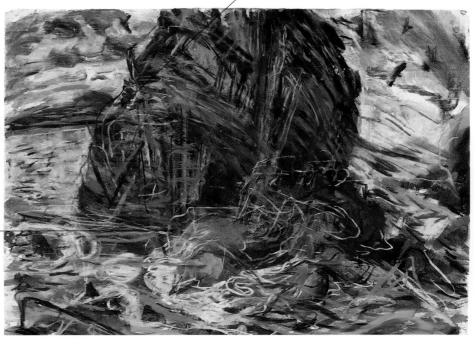

To emphasise the dramatic movement of the waves and wind against the weathered form of the rock the artist has overlaid linear traces of white and ochre pastel onto blended sweeps of a pink and grey. These colourful patterns give the whole piece a sense of movement.

Michael Wright, *Mullion Cove Rocks,* 1994, charcoal, ink and pastel

Female head

In this image, in contrast with the previous painting, the charcoal has been very subtlely blended with the pastel to create a blurred effect and the simplified form and full frontal angle of vision produces an eerie stillness. Paradoxically, the apparent symmetry of the composition amplifies all the nuances of asymmetry contained within the features of the face. This means that our attention is focused on the slight shifts and movements in the form of the features. This is an emotionally taut image, full of a subtle pathos which is expressed in the physical working of the surface. Nervous touches of pastel have been swept across the woman's features which simultaneously emphasizes her emotional intensity and blurs the details of her features.

Creating details

To produce facial details in charcoal and pastel you should aim to combine the two mediums with confident subtlety. To create these lips a rich vermilion pastel has been streaked across a line of charcoal. In the image below the smudged lipstick effect amplifies the mask-like appearance of the woman.

A technique of subtle blending has been used in this detail of the neck. Pastel has been worked into the surface of the support using a finger to merge the pastel powder with the previous application of charcoal.

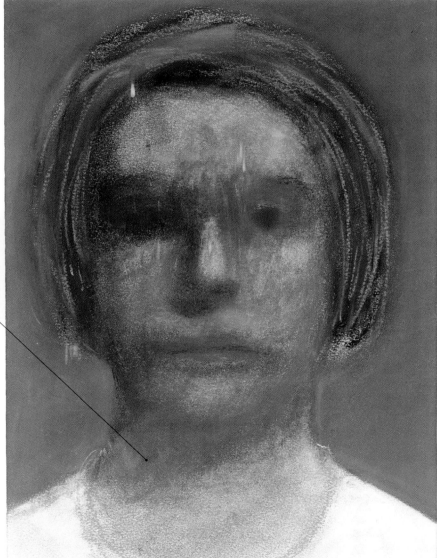

Robert Clatworthy, *Female head II,* 1993, charcoal and pastel

Soft pastels

Used in their full strength, coloured pastels are an extremely powerful colouring medium. However, immensely subtle modelling can be achieved by using the wide range of subtle tints which are available in each of the colours.

Pastel dust

Soft pastels are pure pigment bound in a light solution of gum with the addition of chalk to create subtle tints. Pastel can easily be reduced to dust by paring with a knife. The dust can then be applied to a composition using a brush or ball of cotton wool to create a dry wash of colour.

LINE AND COLOUR

THE MOST COMMON TECHNIQUE for combining line and colour is to add a watercolour wash to a linear drawing medium. The outline is established in graphite, charcoal or ink to create a strong linear arrangement. Once you are satisfied with the organisation of line you can then apply washes of watercolour in increasing strength to add body to the linear structure.

Combining colours
In this expressive rendition of a familiar subject the artist has created strong linear movements and patterns in charcoal to contrast with vibrant washes of watercolour. The weight of the sunflower heads and compact foliage have been amplified by the application of dense line and saturated colour. The work has been completed using a delicate linear drawing in chalk to define the texture of the curling leaves. The artist has successfully combined an analysis of the plant itself with an experiment in mark-making.

Surface interaction
Wet media in the form of watercolour will interact with the surface texture of the support in a very different manner to an application of a dry medium such as charcoal or chalk. The watercolour will retain the shape of the brushstroke and will settle into the pitted hollows of the surface in tiny pools of pigment whereas a dry medium catches the raised surface.

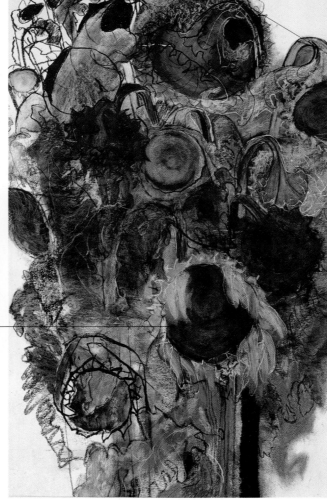

The benefit of using charcoal is that as a drawing media it can be easily manipulated, allowing for alterations before adding a watercolour wash. Charcoal has been used here to create a linear pattern over a watercolour wash to amplify the texture and form of the sunflower.

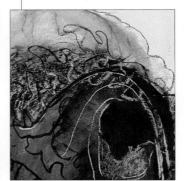

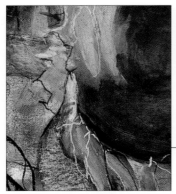

Wet and dry media used in combination create areas of textural contrast. Here the saturated areas of colour created by watercolour paint contrast with the dry texture of the white pastel which has been overlaid in broken lines. The areas of charcoal have been created to give the piece a strong linear structure and added definition.

Susan Lloyd, *The Sunflower Bed,* **1990, charcoal and watercolour**

Ink and wash
Watercolour and inks can be used in different combinations to create effects of either a clear line or of bleeding. Here a sepia line was drawn across a wash of watercolour while the wash was still wet.

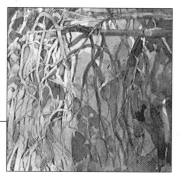

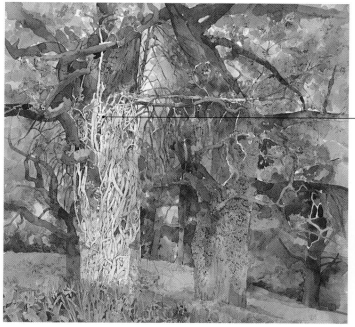

Valerie Claypole, *Ivy Entwined Oaks,* 1988, watercolour and ink

The artist has created a complex linear structure in sepia ink to define the ivy which has then been overlaid with delicate tints of neutral washes. A single area has been left free of colour to focus the viewer's attention on the detailed drawing of the ivy.

Controlled colour

This is a subtle and complex work in which the artist has painstakingly observed the growth of ivy as it envelops the gnarled forms of the oak trees. The linear composition has been developed first in pencil and then in clear unbroken line using pen and sepia ink. Careful applications of delicately controlled washes have been applied to add colour to the composition. The artist has strived to establish a balance between line and colour throughout the composition without obscuring the linear work. The colour key to this composition is a harmony of greens which serves to amplify the parasitic colourless form of the ivy embracing the central tree.

Using colour as shape

Bob Baggaley's semi-abstract work is based on memories of journeying through the Cumbrian landscape. The linear drawing was established using a fountain pen and subsequently overworked in saturated washes of watercolour. The striking arrangement of washes evokes the drama of a moonlit night. The light areas of the composition are amplified by the deep blue of the surrounding border which frames the scene in the manner of a window. Baggaley trained during the sixties and assimilated the pop art and abstract influences of this period into a later preoccupation with landscape imagery. These influences can be seen in the deliberate play of positive and negative shape, in the use of the white of the paper and in the artist's evident delight in the abstract emphasis of the paint surface.

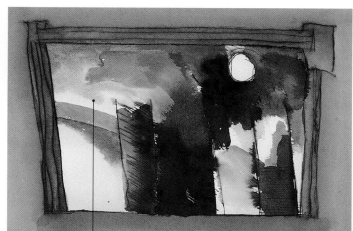

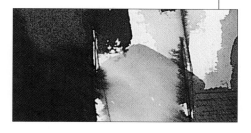

Bob Baggaley, *Westward,* 1989, **watercolour and ink**

The washes of colour have been loosely applied wet-into-wet allowing the colours to run and create secondary mixtures of colour. The overworking of watercolour on ink has caused the ink to lift and bleed into the colours of the washes.

WATERCOLOUR TECHNIQUES

Watercolour is an ideal medium to use in combination with drawing media, either to add tone in a monochrome wash or colour in the full range of hues and tints. Depending on the texture of the support and the technique of application it is possible to achieve a wide range of expressive qualities in wash. You can create dramatically different effects by working wet over dry or wet-into-wet, or by combinations of these two techniques.

Wash on dry wash
By laying a wash, allowing it to dry, and applying subsequent washes in confident single applications you can achieve the effect of distinct overlapping layers of colour. Where the layers overlap the colours will optically mix to create a secondary colour.

Bleeding wet-into-wet
By appying a wash of colour to a wet area of the support or to a previous wash in a wet state you can explore dramatic and spontaneous colour effects. The colours will run and merge into each other creating new colours and feathering movements in the paint.

Scumbling
Use the side of a semi-dry brush to drag a light trace of pigment across the raised tooth of a textured artist's watercolour paper. The effect created is one of a broken surface of colour which allows the previous wash or tone of the support to show through in sparkling flecks of light.

RESIST TECHNIQUES

Oil pastels

Watercolour brushes

ONE INTERESTING MIXED MEDIA EFFECT is created using resist techniques, which capitalize on the tendency of oil to repel water. There are a wide range of oil-based media suitable for resist techniques including oil paint, oil pastels and wax crayons. Another useful resist medium is masking fluid. A design is created using the fluid and overpainted in a wash of watercolour or ink. The resist medium adheres to the support and shows through the subsequent wash of water-based media. Experimenting with resist techniques allows you to exploit bold contrasts of colour or to work with a more subtle range of contrasts by using a closer range of tones. You can use an opaque oil-based colour to contrast with a subsequent wash, or apply a transparent oil or wax medium which will allow the tone of the support or prior layer of colour to show through.

Using wax resist

The master British sculptor Henry Moore consistently used resist techniques in his drawings. In this small sketch book composition he has pursued a sculptural theme of interior and exterior form by using transparent white and yellow wax crayons to resemble a wire armature used by sculptors as a support for plaster or clay. This technique defines the inner structure of the head. The abstract network of wax lines glows through the subsequent wash of dark grey watercolour. The final details of human features have been achieved by a cursive stroke of black chalk on the contour of the head and brushstrokes of black indian ink to define the nose, mouth and eyes.

It is possible to see clearly the way in which the wax repels and causes the watercolour to collect in little spots on the surface of the wax crayon. The density of the shellac-based indian ink drawing has allowed the black line to partially cover the wax crayon in a broken line and magnifies the resist effect on the surface.

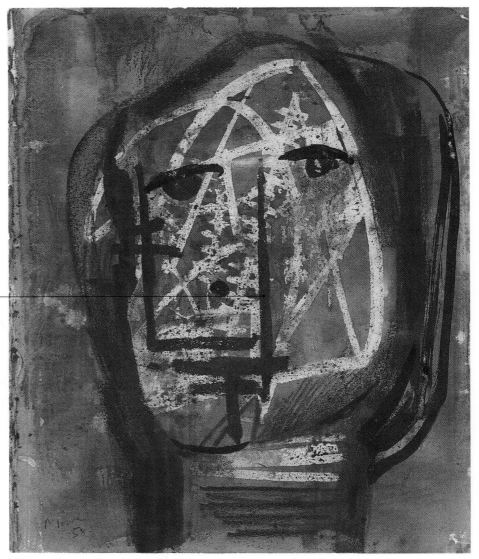

Henry Moore, *Female head,* **1958, wax crayon, watercolour and ink**

Lifting and patterning

The artist chose "Mirage" as the title of this work because the quality of the light and colour suggested the presence of a landscape suffused in a shimmering heat. The work has been developed using an original approach to watercolour. The bands of watercolour wash across the upper section of the painting have been patterned using plastic bubble wrap. The bubble wrap has partly displaced and partly lifted the watercolour from the surface of the support leaving a distinct pattern. This process was repeated using crumpled foil to overlay the middle section, creating a complex overlayering of the two patterns.

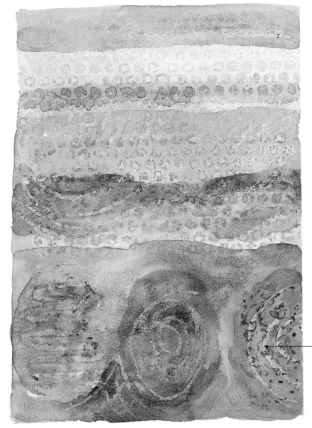

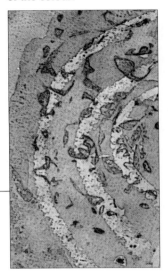

Washes of saturated colours have been bled into each other over concentric circles of pink wax resist line. Before the watercolour dried the artist pressed a crumpled sheet of aluminium foil into the surface using a book as a weight to displace some of the colour.

Masking fluid
This is a latex liquid which is applied with a brush or dip pen to mask out areas of an artwork. After a subsequent wash has dried, the masking fluid can be gently rubbed away to reveal the underlying colour.

Kate Nicholson, *Mirage*, 1994, wax crayon and watercolour

TECHNIQUES FOR LIFTING AND PATTERNING WATERCOLOUR

An exciting variety of textures can be created within the surface of water-based media by pressing materials into the wet paint. Choose non-absorbent materials which have either a distinct texture such as bubble wrap or materials which can be folded and crumpled to create a texture, such as foil or greaseproof paper.
You can also experiment using thin wire, string and grasses. Place the material onto a wash of colour whilst still wet and then apply pressure using a book or board. Lift the material away from the painting as the paint is close to drying and a distinct pattern will remain.

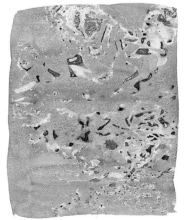

Creased aluminium foil
In this watercolour wash you can see the pattterning created by the use of the foil. The foil has displaced the watercolour into pools of deep colour and the result is similar to light playing on water.

Bubble plastic
The bubble wrap has been applied in the same manner as the foil, left. The uniform orange wash has been drawn into a cellular pattern that has effectively taken a print off the surface of the bubbles in the wrap.

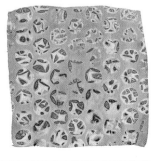

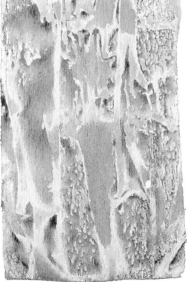

Cling film (plastic)
Placed in contact with the watercolour the surface of the cling film has created a complex pattern akin to marbling.

Materials

Crumpled paper

Crumpled foil

Plastic cling film

Acrylic paint

GALLERY OF DRAWING

DRAWING IS THE MOST fundamental language of visual expression and employs the simplest of media in the forms of graphite, charcoal, ink and chalk. The directness of application when using drawing media allows the artist to develop a composition rapidly in line and tone and to focus on the primary task of organizing a meaningful design. There are many examples of drawings in which artists have enhanced their work using either watercolour, chalks or pastel.

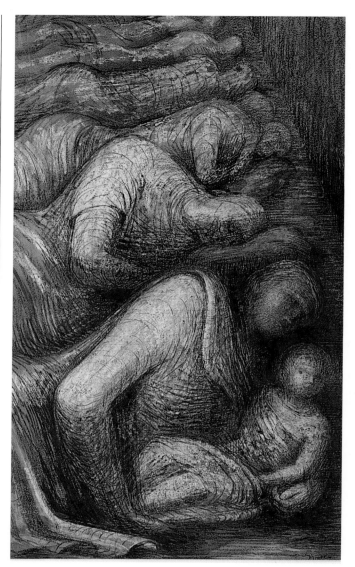

Henry Moore, *Row of Sleepers*, 1941, pen, ink, chalk, crayon and watercolour, *54.5 x 32 cm (21½ x 12½ in)*
Henry Moore (1898–1986) is best known for his international work as a sculptor and his monumental treatment of form was profoundly influenced by Pre-columbian and Romanesque carving. He was commissioned as a war artist during the Second World War and made a series of moving studies of people sheltering in the London underground. This composition, which has religious associations with the Madonna and Child, was developed using his unique technique of overworking wax lines and ink with watercolour.

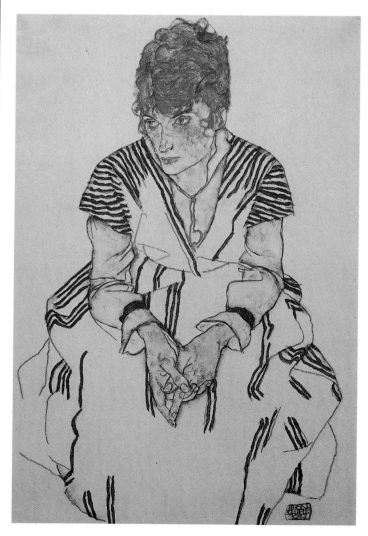

Egon Schiele, *Adele Harms Seated in a Striped Dress*, 1917, gouache, watercolour and pencil on paper *17.5 x 11 cm (7 x 4½ in)*
Egon Schiele's (1890–1918) distinctive style was influenced by, and partly developed as a reaction to, the rhythmical patterns and decorative use of colour in the Art Nouveau movement. In this beautifully observed study Schiele's economical control of line, using graphite, is complimented by a limited palette of warm and cool colours applied in a scumbled application of gouache, adding volume to the figure.

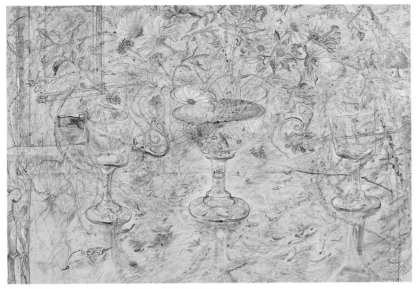

Jones is a supremely sensitive draughtsman who amplifies and embellishes the minutae of his observations of the external world with the imaginative imagery of his internal world. His heightened sensitivity to the rhythms of form and the illuminating nuances of light produce a heady intensity of movement which contradicts the static nature of the still life.

David Jones, *Flora in Calix Light,* **1950,**
pencil and watercolour *56.5 x 76.5 cm (22¼ x 30¼ in)*
David Jones (1895–1974) was both an artist and a poet. In this luminous reverie on light playing through delicate forms of flowers and glass bowls he creates a flux of rhythmical movements that lead the eye on a spiralling journey through the composition. The substance of matter is tranformed and replaced by transparent veils of light and shadow created through the delicate use of line and nervous touches of watercolour.

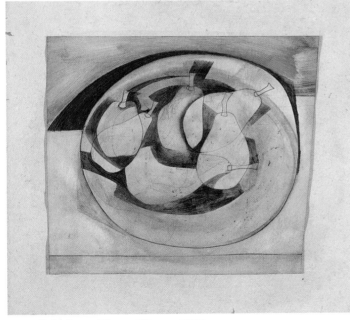

Ben Nicholson, *Plate of Pears,* **1955,**
pencil and oil wash on paper *30.5 x 33 cm (12 x 13⅜ in)*
The drawing's flat surface is emphasized by hatching (closely spaced parallel lines) on the stained surface. An illusion of form is created by overlapping the shapes to create silhouettes.

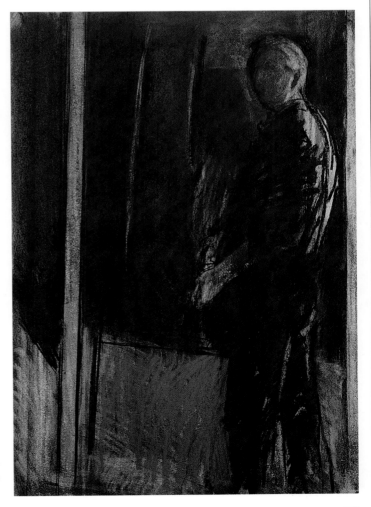

Peter Coker RA, *Le Peintre au Travail,*
1994, mixed media *76 x 56 cm (31 x 22 in)*
In this drawing Coker uses chalk and pastel in a limited palette of black and sombre earth colours creating a tension between the presence of the figure and the surrounding structure of the room.

MULTILAYERED COMPOSITIONS

WATER-BASED MEDIA can be used in combination with a range of other paints to create works of multiple layers. One of the best mediums to use for multi-layered compositions is acrylic. This is because the rapid drying time of acrylic paint allows overworking without disturbing the previous application of colour. Watercolour and gouache can be transformed into paints with acrylic qualities by adding PVA (polyvinyl acetate) to the pigment. You can also paint layers of PVA over water-based washes to effectively seal the paint and allow a subtle build up of coloured layers.

Using PVA glue

This artist has developed a technique of building up an image in layers of gouache and PVA, adding passages of ink to define the strata and texture of the forms in the landscape. By mixing PVA with the gouache or applying it in a wash, the PVA soaks into the pigment giving the chalky gouache a depth and richness of colour. PVA in a liquid state is opaque white but it dries into a transparent plastic film, sealing the absorbent gouache and stopping the ink from sinking into the surface. The effect of combining the black ink and gouache washes is akin to the contrast created by the lead work surrounding luminous areas of stained glass.

Craig Peacock's paintings are lyrical interpretations of the landscape and his work is in the tradition of the British Neo-Romantics, echoing the work of artists such as Graham Sutherland in his concern with the way the imagination transforms the memory of landscape.

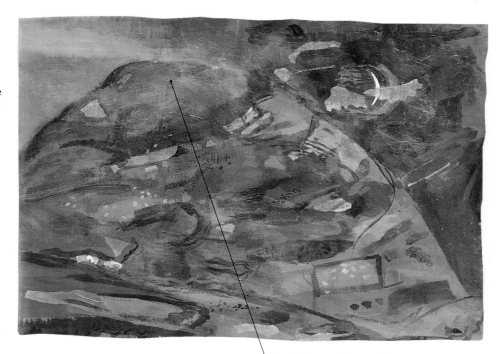

Craig Peacock, *Landscape Cumbria*, 1993, acrylic and gouache,

In this part of the composition the artist has overlaid a thin pale wash of gouache and PVA to push back the underlying black ink lines. This has created a quality of mist in contrast with the more strident tones lower down in the composition.

WET-ON-DRY TECHNIQUE

A richly varied and textured quality of colour can be created in a painting by working layers of colour over each other, using the different qualities of both wet and dry mixed media. You can create the effects of layers of transparent, semi-transparent and opaque colour by overlaying acrylics and gouache and using a technique of wet on dry.

Suspension
The black ink line is suspended between two semi-transparent layers of colour by applying a wash of diluted PVA between each wash of pigment.

Optical mixing
A wash of vermilion acrylic has had an application of saturated red and magenta gouache dragged across it to create the broken effect of optical mixture.

Complementary colours
Turquoise and ochre oil pastels have resisted a wash of orange acrylic and magenta gouache to create a surface of flecks of complementary colours.

Building up the layers

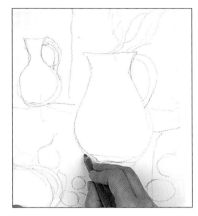

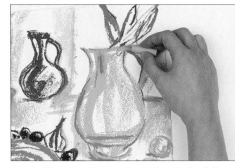

1 ◁ Begin by grouping a small collection of objects, such as jugs, fruit and leaves, then set the arrangement against some tissue paper of a complementary colour. Looking carefully at your still life, roughly sketch in the outlines of the various objects with a soft pastel pencil, on a sheet of hand-made watercolour paper.

2 ▲ Develop the composition by building up the image with a variety of oil pastels, to create areas of vivid and intense colour.

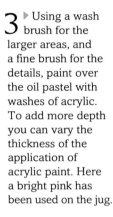

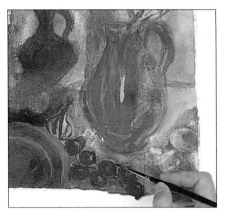

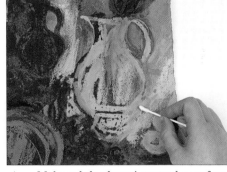

3 ▷ Using a wash brush for the larger areas, and a fine brush for the details, paint over the oil pastel with washes of acrylic. To add more depth you can vary the thickness of the application of acrylic paint. Here a bright pink has been used on the jug.

4 ▲ Make subtle alterations to the surface by over-working with a cotton bud to remove pastel and add texture and detail.

Oil pastels

Scalpel blades

Soft pastels

Acrylic paints

Brushes

Still life

Lucinda Cobley trained as an illustrator and her work, like much contemporary illustration, crosses the boundaries between design and fine art. She uses a variety of mixed media techniques and here she has chosen to work on hand-made paper and use the torn edge to interact with the forms in the composition. The surface treatment and the rough edging encourages us to view the work as a surface of beauty rather than a simple view of objects. To fully exploit the contrasting textures and colours of the different media an open treatment of mark making is used in preference to detailed observations.

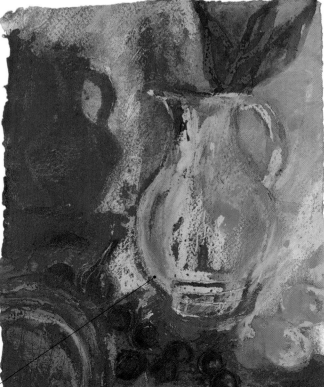

A rich turquoise oil pastel has been overlaid by saturated washes of violet gouache and vermilion acrylic paint. The overall effect is one of a rich layering by working colours over each other using various broken colour techniques. One of the most effective of these methods is scumbling which involves dragging dry paint across the raised tooth of the support.

OIL AND SOFT PASTELS

PASTELS ARE MADE from pure pigment bound by either gum, to form soft pastels, or oil to form oil pastels. Oil pastels have a rich, luxurious texture whereas soft pastels have a subtle powdery bloom. Each type of pastel can be mixed with other media but one of the most expressive combinations is to mix and work the two forms of pastel together. The variations in surface and the qualities of opacity and transparency are dependent upon the contrasting adhesive and blending qualities of each type of pastel.

Combining pastels

Both of the compositions examined here in detail are the work of a superlative contemporary pastelist. Ken Draper is a British artist and an associate Royal Academician who has extended the expressive potential of soft and oil pastel by working these media in combination. Due to the absence of a liquid medium, soft pastels have the highest degree of luminosity of all the painting media. The expressive power of soft pastels is created by the sensation of pure pigment reflecting light but the presence of the oil imparts a

In this composition the artist has achieved a luminous evocation of light playing on the contrasting textures of a shore line. The interactions of the light upon the water are created by alternating applications of pastel, powdered and blended in a dry wash, and oil pastel, applied in dense impasto.

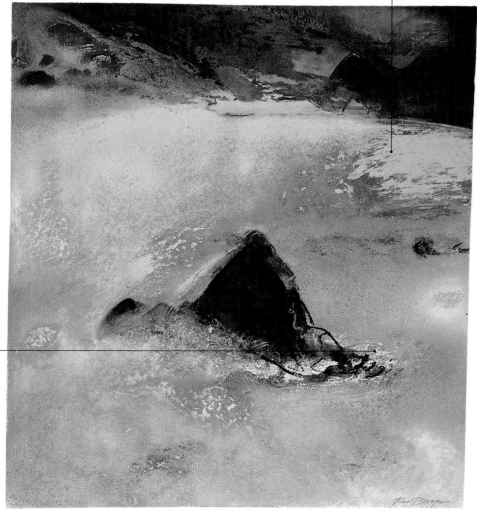

You can alternate between line and tone using either the tip or the side of your pastel. The more pressure is applied the more of the medium will be filed away and held by the tooth of the support. The artist has used the texture of the support to create a grainy line in contrast with the smooth blending of the violet tone of the sand.

Ken Draper, *Recollections,* 1994, oil and soft pastels

saturated depth of tone to the darker colours. Combining these media creates a visual tension of contrasting degrees of luminosity and surface texture. A range of close hues in soft pastels can be crushed into the surface of the support and blended in the manner of a dry wash achieving the most subtle transitions of tone. In contrast the artist uses oil pastels to create abrupt passages of low relief impasto.

The physicality of the landscape

As the son of a miner Draper has a heightened awareness of the physical strata of rocks and the power of the landscape. These works are not realistic views but pictorial reconstructions of the forces and substance of earth. Draper's work is characterized by an intense awareness and subtle manipulation of surface qualities both as texture and as a vehicle for colour. The elemental forces of nature in the form of matter are reconstituted in an inventive control of pigment that celebrates the interactions of form and light.

Unlike other painting media which are controlled with the aid of brushes and thinners, pastel is generally worked directly onto the surface of the support without any tools. There is a freedom and spontaneity in the directness of pastels which encourages an intensity of involvement in the physical handling. Here an oil pastel has been pulled across the raised texture of the support with variable pressure so that it adheres unevenly, creating a broken surface texture.

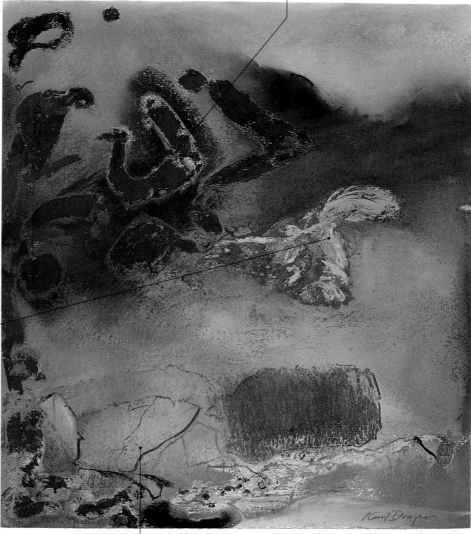

Oil and soft pastels have differing degrees of adhesion. The powder of soft pastels can be displaced and blended into the fibres of the support very easily. In contrast, oil pastel vigorously adheres to the support and when dragged the pastels become more fluid as they are warmed by the heat of your hand or by the air temperature.

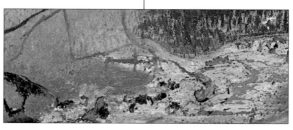

Ken Draper, *Autumn Drift,* 1993, oil and soft pastel

In this lower section of the painting the artist has alternated between bold strokes of oil impasto, evoking seaweed, and a subtle blending of soft pastel which has then been overlaid by areas of scumbling and stippling.

EXPERIMENTING WITH SURFACE

AN EXCITING DIVERSITY of surfaces can be created by using watercolour, gouache and acrylic paints in combination. Depending on the degree of paint dilution and the texture of the support you can vary the power of the paint from a transparent wash to a full opaque impasto. Acrylics are designed to work in the widest range of painting techniques and there are additives which are manufactured to give different qualities of bulk, transparency or lustre to the paint. In addition to the inherent qualities in the paint there are tools available, including brushes and rollers, which can determine the character of the paint surface.

Broken surface
The nature of your support will have a fundamental effect on the surface of the paint. This broken surface effect was made by scraping the paint across a heavily textured paper using a metal painting knife. The paint has been forced into the pitted surface of the support leaving the raised tooth of the paper free of paint.

Gouache impasto
Gouache has been applied in impasto over a water-colour wash in which two colours were blended wet-into-wet.

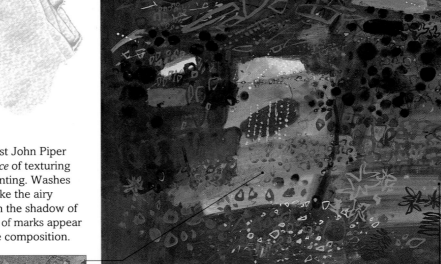

The renowned British artist John Piper has engaged in a *tour de force* of texturing and markmaking in this painting. Washes of grey, blue and green evoke the airy sensations of a landscape in the shadow of dusk against which patterns of marks appear to dance in the space of the composition.

John Piper, *Landscape* 1968, watercolour, ink and gouache

The surface of the composition has been built up in successive layers of paint. The orange pattern on the left has been washed over and dispersed into a subtle warm grey wash by mixing with the underlying blue. Blue is the complementary colour to orange and on the right-hand side the artist has superimposed scumbled patches of orange in strident contrast with the underlying turquoise blue.

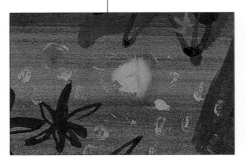

Creating an illusion

The range of painting techniques, from watercolour washes to opaque mark-making, can also be achieved in acrylic. Whereas Piper has used overlaid washes as a base for a rhythmical counterfoil of irregular and linear marks in gouache and ink Boyd has capitalized on the properties of acrylic to create areas of dense impasto. Both artists have layered paint causing the marks to appear to advance and recede as though suspended in space.

Areas of deep pink, ochre and a tint of ultramarine blue were laid onto a dried grey surface in loose impasto. While the paint was still wet a large decorator's roller was used to roll the colours across the support. A splash of white paint was then pushed across the surface and the blunt end of a brush used to score lines in the pink and ochre sections. Lastly a strip of painted paper was collaged into the wet surface.

Texturing with acrylics

This artist engages in an experimental approach, exploring the plasticity of acrylics and so places particular emphasis on rich texturing properties of impasto which can be achieved using this medium. This abstract work was developed from studies of the forces and actions of the sea against coastal rocks which the artist has expressed in an equivalent painterly form through the gestural treatment of the paint surface.

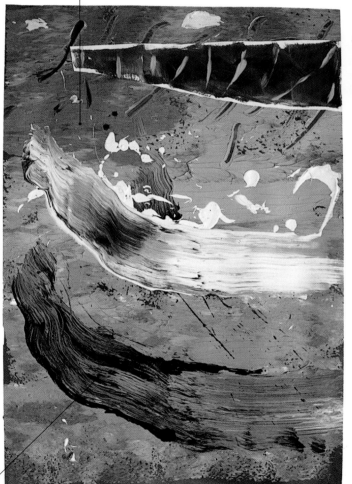

Graham Boyd, *Untitled*, 1993, acrylic and collage

Black paint was laid on the wet surface of the underlying paint and a large brush was used to pull the fresh application of paint across the surface. A composition that has been worked in impasto will record, in a precise imprint, the actions of the hand, which in turn reflect the thoughts of the artist.

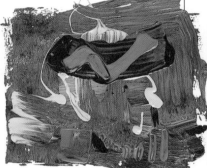

Wet-into-wet

Acrylic paint can be worked either wet-into-wet or wet on dry. In this example paint has been applied wet-into-wet. Red and yellow have been mixed together to create a rust orange. The colours were worked into each other on the support and an application of yellow was dribbled and brushed into the orange. Lastly strokes of green and red were laid in single movements to avoid mixing with the underlying colours.

Iridescent acrylics

Blue acrylic paint has been mixed with gel medium and applied with a painting knife to create a passage of impasto. The paint was allowed to dry and then a dilution of gold acrylic was applied over the impasto surface to imbue the surface of the blue paint with a metal lustre.

ADDING TEXTURE

PAINT IS USED PRIMARILY as a colouring medium but it also has a texture which can be manipulated in different ways. You can explore an extensive range of surface textures by adding various materials to the paint, including coarse sand, man-made fibres or even by gluing additional sheets of paper to the support. Irregular textures create a visual disturbance that will significantly effect your perception of the colour because of the way the light is reflected from the textured paint surface.

Choosing your materials

A diversity of texture can be created by using different materials and methods in your composition. You can work onto a uniformly textured readymade support such as a rough paper or canvas, or create areas of contrasting texture by gluing thin sheets of flexible materials, such as cloth or paper, between the layers of paint as shown here.

The artist has laminated shapes (cut out of sheets of tissue paper) to the support to suggest natural forms, but also to intensify the expressive quality of the paint surface of the composition. The creases and edges of the tissue paper have created a heightened sense of surface texture as well as amplifying the feeling of the movement of shapes across the picture surface. By applying tissue paper with PVA glue the paper is turned into a semi-transparent film and after being laid over an existing wash it will modify the underlying colour in the manner of a watercolour.

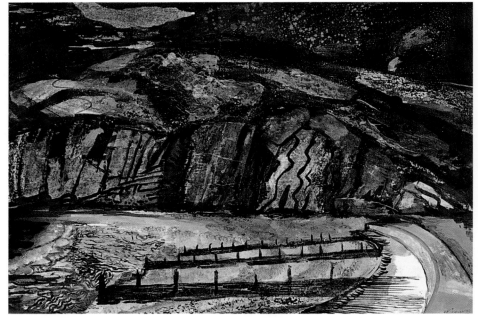

Craig Peacock, *Rite of Spring*, 1993, mixed media

Using tissue paper and glue
The textural range of your surface can be changed by laminating tissue paper onto the support using PVA glue. You can either use cut shapes, or fold and corrugate the paper to create a low relief surface texture which can be either regular and rhythmical or random and erratic.

Once you have glued a sheet of tissue to your support you can paint over using any type of paint to emphasize the texture of the tissue.

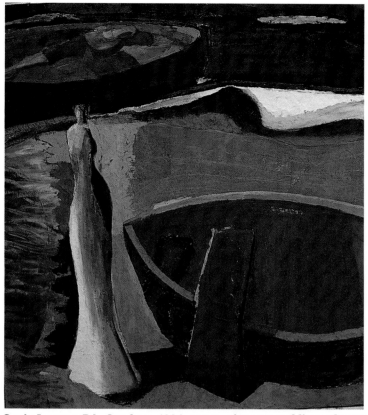

Sonia Lawson RA, *Seashore*, 1994, gesso, pigment and linseed paste

Powdered pigment

Textured gesso

Amplifying the surface

Sonia Lawson RA is a painter whose work epitomizes expressive synthesis of colour and texture. The physicality of the forms within this enigmatic composition have been amplified by the pronounced granular textural quality in the paint surface. This has been achieved by mixing pigment with linseed paste to produce a more heavily textured paint than those manufactured by artists colour makers and sold in tubes. The textural qualities of the paint surface can also be increased by using a textured gesso which contains carborundum and is sold in different grades of coarseness.

Linseed paste

ADDING TEXTURES

Gesso can be used to create a textured surface or, alternatively, you can add inert materials, such as sand, to either the gesso or the paint. Recently some manufacturers have produced textured acrylic mediums that contain fibres which impart a distinctive irregular texture to the paint.

Fine sand
Sands come in different grades from fine to coarse or you can use a sand which contains different granules to create an uneven texture.

Acrylic mediums
Acrylic mediums contain either granular or stringy fibres. In the example (right) a stringy fibre medium has been added to acrylic colour whereas on the left a more granular paste mixed with turquoise pigment has created a more pronounced texture.

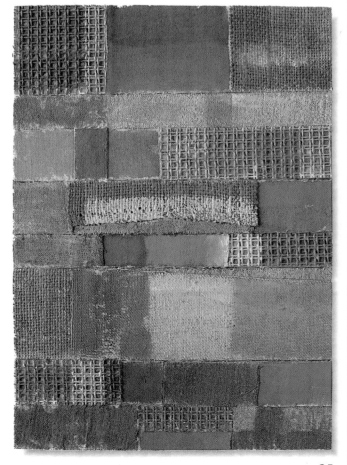

Colour and texture

In this heavily textured composition the artist has deliberately arranged different collected grades of canvas supports which she has collaged into a pattern of contrasting surface textures. Depending on their degree of intensity and their proximity to a neighbouring colour all colours will either advance or recede in the picture space. The use of primary and secondary colours results in the colours pushing and pulling against the surface texture of the collaged materials.

GESSO AND WAX

A PAINTING IS FIRST and foremost a surface of texture and colour and irrespective of whether it is abstract or figurative the power of a work relies on the skill and care with which the surface of the work has been developed. Gesso and wax, used separately or in combination, are two media which produce an interesting array of surface qualities.

Gesso is commonly used to prime a board or canvas in preparation for the application of a paint medium. It is normally applied on an even, flat surface but it can also be used creatively to develop a low relief design within the surface of a composition. Beeswax is a semi-transparent medium which produces unique surfaces of paint texture.

GESSO IS AN ANCIENT preparation for priming a painting surface in readiness for paint. Originally gesso was made from chalk and glue with the addition of small amounts of oil to add flexibility. Manufacturers now produce an excellent modern gesso which is highly flexible and made from acrylic, titanium and chalk.

WAX ENCAUSTIC PREPARATION

Wax encaustic is made from beeswax which has been gently melted to a liquid state in a double boiler. This warm wax can then have powdered pigment added and can be used as a media when the wax is still warm. A small amount of damar varnish can be added to strengthen the medium which causes the wax to set on the support within seconds, to form a durable surface.

Solid beeswax
Bees wax is one of the oldest painting mediums known and wax paintings have survived since the Egyptians. Wax does not crack, flake or darken with age.

Turpentine
Another wax encaustic technique involves blending turpentine and warm wax in a 50-50 ratio. This mixture should set to a buttery consistency.

Melting wax
Place the wax in a tin within a pan of hot water.

The final mixture
When the wax is mixed with turpentine it forms a soft paste which will impart the characteristics of wax to the oil paint when mixed in equal quantities. It must be kept in a sealed container to stop the wax from hardening.

Drawing into gesso
A design has been drawn into the surface of the gesso using the end of a brush. You can also add materials to create more texture.

Applying the wax
Here the gesso has had an application of orange wax encaustic scraped across the surface depositing the colour in the indentations.

A layer of purple and orange wax encaustic has been scraped across gesso. An impasto layer of beeswax without pigment has then been applied with a knife.

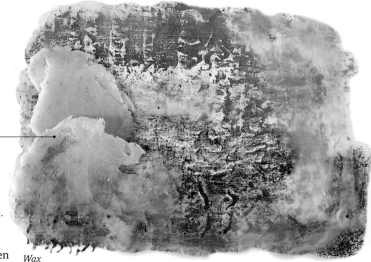

Wax encaustic

Texture and geometry

In this powerful composition the artist has created a beautiful surface using wax over four square panels. The surface was constructed using layers of crepe paper and liquid wax and afterwards colour was added using oil paint and a metallic pigment. The work intends to inspire religious meditation and was designed to be housed in a large space with the symbolic positioning of the four squares to form a single square, giving the piece a sense of sacred symbolism. The artist has developed a complex textural surface as a source of reverie to complement the severity of the geometry.

Wax and tissue
Poured wax sets in different thicknesses over tissue paper that has been soaked and draped over the surface of the canvas board.

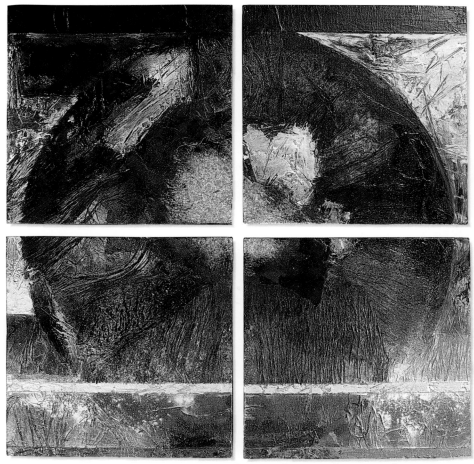

Maureen Wilkinson, *Revelation,* 1992, collage and encaustic on wood

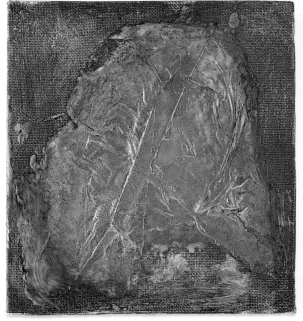

Suspending materials in wax
You can use wax to separate and suspend materials or paint within semi-transparent layers of wax or add pigment to create an opaque wax medium. Here a sheet of tissue paper was soaked in warm wax, a layer of metallic pigment was brushed into the surface and a thin wash of blue oil paint applied to the surrounding area.

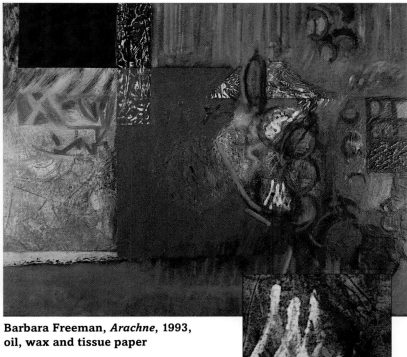

Barbara Freeman, *Arachne,* 1993, oil, wax and tissue paper

The webs of gesso evoke the myth of Arachne; a weaver who is turned into a spider as revenge by the Greek gods.

UNUSUAL MATERIALS

CONTEMPORARY ARTISTS are often concerned with testing and extending the bounds of visual expression to incorporate unusual materials in the creation of their mixed media compositions. This originality has occurred as artists have searched for materials to fulfill a particular quality of colour or texture that is usually outside the scope of more orthodox materials. As a result the conventional formats have been challenged as artists find alternative shapes to use instead of the familiar rectangle of paper or canvas.

Using the landscape
Tessa Maiden was raised in a farming community and her choice of materials and work reflects her awareness of the structure of the landscape. In the two paintings on this page she has used a highly unusual and inventive arrangement of natural, artificial, regular and irregular forms. These two pieces were originally part of a vertical arrangement of eight subtely different canvases.

In contrast with the regular pattern of the empty tea bags the artist has created a visual nucleus in each composition by using the contrasting textures of a patch of canvas and radiating lines of string. In the lower half of the canvas a mixture of boot polish and linseed oil has coagulated into patterns on the surface.

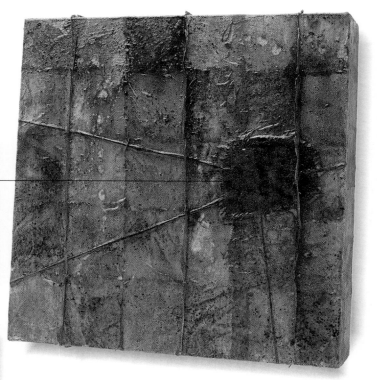

Tessa Maiden, *Tissue Culture No.1,* **button polish, tea bags, linseed oil and string**

Using tea bags
The artist has used the teabags to represent the division of land into fields.

Tessa Maiden, *Tissue Culture No.1,* **button polish, tea bags, linseed oil and string**

Tea bags

Using metals and wax

The circle is a very pleasing format to work with. Free from the constraints of verticals, horizontals and right angled corners, the imagination can explore another world of associations. In this composition the artist has beaten a thin sheet of copper over a wooden panel and coated the copper surface with a layer of melted wax. The wax was darkened with the addition of pigment and areas of the impasto wax surface scraped away to reveal the uneven texture and reflective surface of the beaten copper.

The qualities of wax

Wax is a versatile medium which can be used to alter the qualities of a surface. A light application of wax thinned with turpentine will deepen the tone of wood or stone and will also add transparency to a paper surface.

**Rowena Dring,
Untitled, 1993,
tempera, pigment
and wax**

Using slate

Slate is an ancient building material and would normally be associated with sculpture rather than painting. Here the artist has used slate to create a work which could be defined as a wall sculpture but whose surface is read in the manner of a painting. A shape which is evocative of land mass has been created by carving into the edges of the slate and then through a subtle texturing of the surface.

**Rowena Dring,
Diskworld, slate,
and plastic padding**

Natural slate

39

GALLERY OF PAINTING

PAINTINGS CREATED BEFORE the 20th-century were largely figurative – using artistic conventions such as perspective they offered convincing pictures of the world as we knew it. Contemporary art is often more abstract resulting in more attention being focused on the picture surface itself – emphasizing colours, shapes and textures. This has resulted in an extraordinary period of experimentation in which artists have used a huge range of materials to produce an exciting array of mixed media works. Artists have concentrated on generating a new awareness of surface and have succeeded by adding materials, using impasto techniques and by scraping and inscribing a surface to amplify the characteristics of each medium.

Nicholson has used an unusual vertical, double square, format for this large canvas and worked the surface in colours and textures that are similar to weathered stone. There is a structure of shapes within the piece which complement the diffuse texture of the paint. The finely scraped layers of grey paint reveal previous applications of colour and create the sense of an underlying strucure being rediscovered.

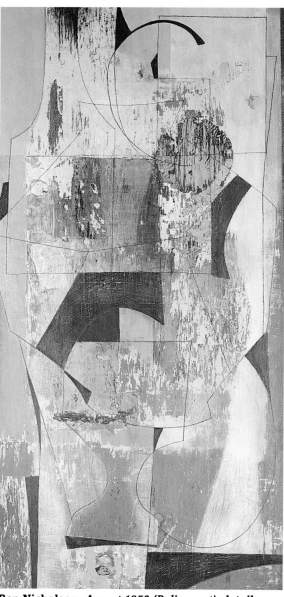

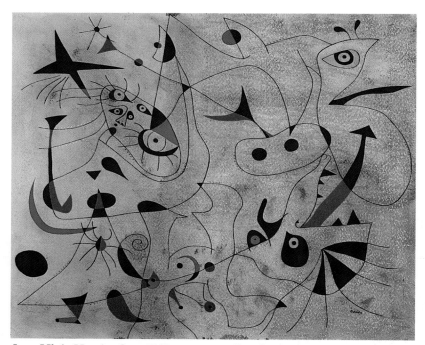

Joan Miró, *Morning Star,* 1940, tempera, oil and pastel *38 x 46 cm (15 x 18 in)*
Joan Miró (1893–1983) was one of the major Surrealists, and here he employs a perennial surrealist device; the juxtaposition of incongruous subjects to disturb our normal perception. In this piece Miró demonstrates the combination of wet and dry painting materials by rubbing pastel into the support to amplify the texture of the surface and contrast with the opaque painted shapes. A menagerie of beasts are linked by a linear framework and form a dreamlike constellation which floats against the nebulous vapours implied by the pastel wash. Miró was profoundly influenced by his Catalan roots which he expresses in strident patterns and the inventive use of textured materials.

Ben Nicholson, *August 1952 (Palimpsest),* detail oil and pencil *107 x 53 cm (42 x 21 in)*
A "palimpsest" is a piece of paper or parchment on which the original text has been obliterated to make room for other writing. Nicholson has built up subtle layers of paint by wiping and then scraping back the pigment on a textured surface.

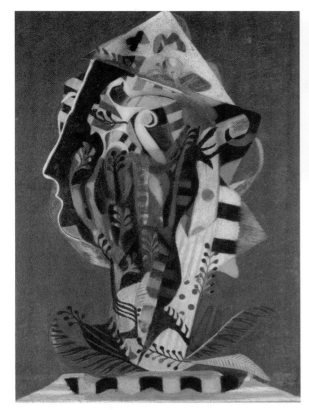

Eileen Agar, *Orpheus,* 1991, pastel and chalk
84 x 61 cm (33 x 24 in)
Eileen Agar's use of vibrant coloured chalks and pastels evokes the beguiling power of music and prompts an imaginative reading of the head in profile as the entrance to an underworld of dreams. The image has been imbued with a visual lyricism and the inventive use of organic shapes evokes a pastoral theme.

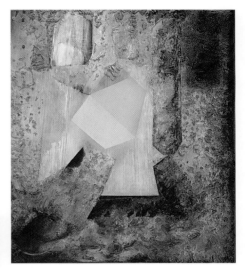

Ken Draper, *Light Fall,* 1993, oil and pigment on wood, *122 x 107 cm (48 x 42 in)*
In this startling mixed media composition the artist has employed an innovative combination of oil paints with pure pigment in powder form. The wood grain has been stained using oil paint to amplify the support and rectilinear shapes have been delineated in masking tape. Draper has created extremes of texture by blending pigment into the smooth surface of the wooden panel as a foil to the low relief surface created in oil paint. The painting is a compelling allusion to the structure of the earth's crust.

The artist has scraped through the layer of gold in a sgraffito technique to create an inscribed pattern of foliage. The allusion to vegetation has been amplified by the use of a Viridian green which has been glazed over the gold. This detailing emphasizes the monumental scale of the towering gold edifice.

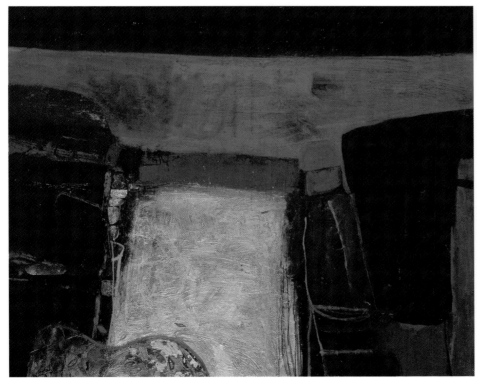

Barbara Rae, *Field Altandhu,* 1994, pigment with gold paint, *170 x 194 cm (67 x 76 in)*
In this large scale work the artist has evoked an exotic night through a sumptuous combination of iridescent gold pigment and saturated colours. The surface of the support has been textured and reworked in layers of pigment which can be seen in the shimmering surface of the area of gold. The deep blue unifies the broken surface and throws the iridescent gold and luminous red band into high relief.

COLLAGE MATERIALS

COLLAGE, LIKE ANY OTHER ART FORM needs to be held together by a visual theme, either by a dominant colour, an emphasis on contrasting textures or a linking concept such as landscape. Once you have established a theme you can experiment with collaging almost any inert material that you can stick to a sheet of paper or to a board. Any light material such as plastic and cloth can be attached to a heavy weight paper support using glue. Heavier wood and metal materials are best attached to a stronger support of either a board or panel.

THERE ARE A WEALTH of coloured and textured materials to be found for collaging including, tissue papers, newspaper imagery, magazines, posters, books, wallpaper, packaging and cardboard. An experienced collagist soon learns that "junk" can be rearranged to form a compelling art work, and develops the habit of collecting and storing a large selection of found materials to form a storehouse of stimuli for the imagination. Suitable materials for low relief collages are light metal sheeting, aluminium foil, thin plywood and veneers. You can also use flexible linear materials like string and wire to add curvilinear shape to your composition. The average home is a great source of materials, not only for the wide selection of disposable card, plastic and paper that accumulate in the home, but also for the range of dried foods to be found in the kitchen, such as grains, pulses and pastas. However, it is important to only use food materials that will not disintegrate when exposed to the air.

Printed material
Newspapers, magazines and brochures provide a surfeit of disposable printed material and imagery. The fonts and scales of the letter forms are particularly useful.

Old photographs
Most holidays and events result in a number of unwanted photographs. These can be filed into subjects and used to form collages on different themes and they can also inspire a colour theme.

Assorted fabrics
The delightful and seemingly endless diversity of natural and synthetic fabrics are highly suitable for collage. Fabrics can be grouped and organized in a composition according to texture and colour. You may wish to begin with contrasting patterns of printed cotton or the different weave and textures of canvas and sacking.

Burnt tin can

Found objects

Discarded items and broken household appliances can be dismantled to retrieve small machine parts to inspire ideas. Complex electrical parts, along with broken toys, provide a ready supply of diverse shapes and forms which can suggest themes to explore in collage.

Discarded toys & shapes

Copper wire

Pumice stone

Tin foil pie-case

Glue gun & glue sticks

Wood glue

PVA glue

Found natural objects

A walk through a garden will provide many natural, beautifully textured leaves, twigs, seeds, grasses and barks which are very suitable for collaging. Beaches are useful hunting grounds for artists and works can be developed from weathered fragments of rope, driftwood and stones. The beauty of these fragments is that they are textured by the action of the sea.

Found objects

Adhesives

For light paper and fabric materials a PVA glue is ideal. There are a range of wood glues which are suitable for plywood, veneers and driftwood but they take some time to dry. A helpful tool for low relief collage is an electric glue gun which heats the glue and squeezes it through a nozzle onto the support. This is particularly useful for metal and stone.

Cutting implements

Paper and card are quickly cut to shape using either a sharp craft knife or a pair of scissors. A useful addition to your tool kit is a pair of tin snips which can cut thin sheets of tin and mesh.

Tin snips

Fretsaw

The fretsaw is a saw which is designed to allow for the cutting of complex shapes from thin sheets of wood. The thin saw blade is held in tension and can easily cut and form curves.

PRINTING MATERIALS

PRINTMAKING MAY SEEM a forbidding prospect, requiring access to presses and a printmaking studio, but it is possible to create a range of fascinating and creative prints without the necessity for expensive machinery. Printing is basically the process of lifting an impression from a surface that has been inked up or, alternatively, pressing painted shapes onto a paper surface. There are many materials which are suitable for printmaking and it is a simple process to develop works of striking texture and colour using inexpensive tools.

Roller with ink

Wooden spoon

Palette knife

THE MOST POPULAR method of creating a print is by relief printmaking, which involves either cutting into, or building up, a printing surface into a pattern of raised shapes. Ink is then rolled over the surface of the printing block and a sheet of smooth paper placed on the inked surface. Even pressure is then applied to transfer the design onto the paper. Pressure is best applied by using either a roller or by rubbing the convex side of a wooden spoon across the back of the paper. Another highly creative process for you to explore is monoprint which involves painting a design onto a sheet of smooth impervious material such as acetate or glass. Again take a print by rubbing on the back of the paper with a roller or spoon.

Masking out
Masking tape is designed for blocking out areas of a composition before an application of paint or ink. The tape is then peeled away from the surface allowing the underlying tone to show through. Masking tape is also essential for securing the paper to prevent movement when taking a print.

Ink and surfaces
Inks should be mixed with a spatula on a palette of either plate glass or, as a safer alternative, a sheet of acetate or plastic. The ink should then be taken up with a roller, lifting enough ink to apply an even application to the printing block. As you roll you can control the thickness of the ink to create either a transparent or opaque application.

Brushes
Different sized brushes are used in monotype printing to apply and move the ink around on the plate to create areas of line or tone. Brushes are also used as an alternative to the uniform application achieved by rollers.

Scalpel
Scalpels are useful for carving patterns into sheets of paper and card for printing.

Printing inks
Printing inks are made up of finely ground pigments suspended in a transparent drying medium. They come in an extensive range of colours but by mixing the three primary colours of Magenta, Cyan and Yellow, along with black and white, you can create a full palette of colours. Most commercial inks are oil based and are thinned with white spirits but you can also buy water-based inks. Manufacturers make an extending medium for oil- based inks that can be added to create transparent tints.

Shellac

Shellac is a resin based varnish which is used to seal the surface of a low relief work or collagraph. It is useful for oil or water-based inks, as the dried application of shellac stops the card from absorbing the ink. Without a layer of shellac the surface of a low relief card print will deteriorate in contact with the ink allowing only a few impressions to be taken.

Shellac

Turpentine

Linseed oil and turpentine

Linseed oil is used as an extending medium for printing ink and oil paint and will increase the transparency of the colours. Turps is used to clean the roller at the end of a printing session.

Linseed Oil

Rubber stamp

Positive and negative card cut-outs

A piece of jigsaw puzzle

Plasticine mould

Plasticine mould

Wooden stamp

Printing blocks

Card is easily cut using a craft knife or scissors to form a suitable printing block. Rigid shapes can also be cut from hardboard or plywood using a fretsaw. Other more easily cut materials include balsa wood and polystyrene. You can also take impressions from surfaces using plasticine which can then be used as a short term printing block.

Variety of textures

There are a wide selection of man-made materials which can be either cut or crumpled to create a textured surface. Each material is capable of different patterns by either folding to create regular creases or crumpling to create irregular patterns in the folds. There are other interesting textures in surfaces which have been manufactured with a low relief surface, such as certain wall papers, bubble wrap and woven fibres.

Cling film

Aluminium foil

Using found objects

Collagraphs can be made from a diversity of materials, including string and thin wire which are ideal for creating curved lines. These shapes can be used in contrast with the more regular weaves of gauze and other heavily textured fabrics. Pulses such as rice can be used to create a pattern of small marks.

Bubble plastic

Tracing paper

COLOUR COLLAGE

COLLAGE IS A TECHNIQUE of cutting and arranging coloured or toned materials to form a composition of shapes. This allows for extensive exploration of possible arrangements and affords scope for many adjustments before fixing the shapes in place. A major advantage to collage is that you can build an arrangement rapidly, which encourages a confident and inventive treatment of composition. A colour collage also makes an excellent base for additional mixed media techniques using paint and found objects.

Using your sketches

The artist has developed a dynamic compositional theme based on life drawings of the figure in motion. The implications of translating the drawing into collage are that the shape becomes the sole means of expression as the process of collage reduces the figure to flat shapes. The artist has selected angular and curved shapes from his sketches to emphasize movement.

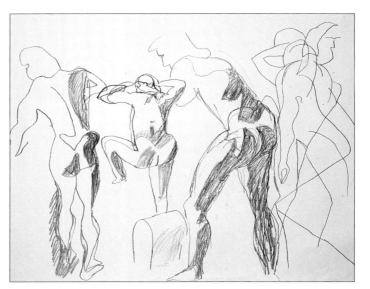

A collection of sketches

By placing a number studies on the same sheet interactions of positive and negative shapes occur, acting as a prompt to the imagination.

1 ◀ The artist has carefully transferred selected shapes from his drawing onto hand-coloured sheets of paper and cut round the outline using a pair of scissors. The sheets were prepared using a large brush to apply a quick-drying wash of acrylic. An alternative is to buy a selection of ready-coloured sheets from paper suppliers who sell a wide spectrum of coloured sheets specifically designed for collage.

2 ◀ The dominant concern of collage is forming and arranging expressive shapes. As a means of intensifying the character of the shapes the artist has chosen to vary the texture of the edges of the forms by alternating between the sharp edge of a shape cut with scissors and the ragged edge created by tearing the paper.

NEGATIVE SPACE

Composition is profoundly affected by having to translate a three-dimensional world of forms onto a two-dimensional surface. This process creates new shapes in the subject but they only come into existence on the picture surface. They are the negative shapes which are created between the positive form of the subject and other areas of the composition. The negative shapes are as important as the positive shapes and it is in collage that this awareness of composition can be most fully developed into a sophisticated image.

Maximum effect
The cut shapes have been shifted in this collage arrangement until the maximum interaction between the positive cut shapes and the negative shapes of the remaining areas of the support has been achieved.

Overlapping
The original leaf design has been transformed into a complex interaction of positive and negative shapes by the simple process of overlapping.

Scale and format
It is vital to consider the relationship between the position of the positive shape and the scale and format of the support. Here the shape is placed in an uninteresting static position creating no interaction.

Positioning the shapes
The positive white shapes have been carefully positioned to touch the edge of the support and each other creating dynamic negative red shapes among the positive shapes.

3 ▲ Where the shapes overlap contrasting areas of primary and secondary colour create a tension of positive and negative shapes in the composition.

Making connections
In the final composition there are two movements leading the eye through the artwork in different ways. Through the recurrence of curved lines and the repetition of colours which create alternative sets of connections.

PHOTO-COLLAGING

COLLAGING PHOTOGRAPHIC IMAGERY has become a mainstream contemporary art form which is both a product and mirror of our technological age. Technology now provides us with a perpetually renewed fund of ready made printed imagery in the form of magazines, advertising, posters and newspapers. We also create personal imagery using our own cameras. The essential principle of collage is to arrange cut shapes to either an aesthetic or conceptual theme. Imagery for the collage can also be manipulated by using either a photocopier or a computer.

A selection of cut out images

Choosing a theme

Through selection and organisation collaging can result in powerful contrasting visual qualities of form, as can be seen in this surreal photographic montage by Ed Smy. The artists working method is to select and store imagery according to themes, for example machines, organic forms and faces which are used as a fund of potential collage imagery. The collage was constructed by carefully arranging large areas of colour to create a dominant colour key and a stage-like illusion of space. As a sculptor Ed Smy is interested in the expressive power of combining familiar forms in a new context.

Composing your collage

Collage can be used to draw images from our unconscious and to create compositions that reflect the incongruous juxtapositions that confront us daily. In the home magazines and television flood our imaginations with imagery. In the street billboards jostle for attention among the multitudes of commodities displayed in shop windows. This bombardment of imagery gives modern life a surreal quality which is most readily mirrored in this witty collage.

Ed Smy, *Vaudeville,* 1994, Photo-collage

Reduction and enlargement

The photocopier has given the contemporary artist exciting new effects to exploit in collage. New artistic possibilities are generated through the ease with which these machines reduce and enlarge printed imagery in both colour and monotone. The photocopier, like all print forms, has its own particular quality of tone and texture, exaggerating the tone to either black or white.

Creating symmetry
In this unusual arrangement an image has been repeated and cut into irregular shapes. The cropped image of a building frontage has been lifted into a new reading as a symmetrical abstract design of black and white textured shapes.

Architectural patterns
In this collage the artist has used a photocopier to enlarge and reduce original photographs to the scale necessary for the composition. Images of architectural structure have been repeated and collaged over textured and painted papers to create an inventive painting.

Repeat patterns
Any image can be constructed into a repeat pattern within minutes allowing the artist to make rapid decisions and significant changes without difficulty. Here a photograph of heavily textured stacks of wood has been repeated using four sheets to create a single composition which has taken on the potential to work as a textile design.

HANDMADE PAPER

Materials

Mixing bowl

Measuring jug

Plastic bowl

Shredded paper

Electric food blender

MAKING YOUR OWN PAPER is a surprisingly simple process and a useful skill to master for creating unusual mixed media pieces. There are a range of qualities of surface which can only be created by making your own paper. To do this you will need to buy some basic materials including a mould and deckle, which is a fine mesh stretched over a frame to catch a thin layer of pulp. By the simple process of soaking and shredding existing paper into a pulp you can create a raw mixture that you can work in many ways. You can either add pigments or dyes to create colour or blend in a range of other fibres.

Making your own paper

2 ▷ The pre-soaked paper mixture needs to be liquidized to reduce it to a pulp. This can be done in an ordinary food blender in about 30 seconds. If you want to create a coarse pulp liquidize for only 10-15 seconds in short bursts.

1 ▲ Tear up old paper and place the shreds of paper in a bucket. Add a large jug of hot water making sure you fully submerge all the paper. Leave the paper to soak for at least an hour or ideally over night.

3 ◁ Fill a plastic washing-up bowl half full with tepid water and pour in the pulp mixture out of the liquidizer. A half full bowl of water should only take one liquidizer load of pulp. Stir the mixture to disperse the pulp.

5 ▷ It is important to get an even covering of pulp on the mesh. The mould and deckle should then be lifted out horizontally, allowing the excess water to drain off.

4 ▲ Before lifting out the pulp you should prepare a board by placing jay cloths over wet newspaper laid over a wooden board. Submerge the mould and deckle, mesh side up, at a 45° angle, into the mixture.

6 ◁ Making sure the prepared surface is very even and moist quickly flip over the mould and deckle and place the frame face down onto the jay cloth.

Materials

Jay Cloths

8 ▶ It is extremely important to bounce off the mould and deckle in a quick clean movement. This is done by holding one end firmly and bouncing off the opposite side. This should leave the layer of pulp on the board.

7 ▲ Stroke the surface of the mesh to sponge off some of the excess liquid and flatten the pulp onto the jay cloth. You can build up layers of paper by placing a wet jay cloth between each layer of pulp.

9 ◀ The pulp should be left to dry into sheets of paper. This can be done by leaving the layers of pulp to dry together in a pile or by taking each jay cloth and hanging it up to dry on a line. The paper should only take a couple of hours to dry into a sheet. Once dry the paper should be carefully peeled off and sealed using starch, gelatine or PVA glue.

Mould and deckle

USING ADDITIVES

Natural Additives

To add interest and texture to your paper all kinds of material can be added to the paper pulp – ranging from dried grasses, leaves, petals, seeds and thin bark to different grades of textured and coloured papers, threads, cottons, string and nylon netting. There are different ways in which you can add your collected materials to the prepared paper pulp. You can break up plant and paper fibres by liquidizing them into your paper pulp and this will create flecks of various colours and textures in the paper. This is an excellent method for creating sheets of paper of a uniform texture and subtle variations of colour. The size of the additional fibres can be varied by the amount of shredding the fibres undergo in the liquidizer and you can create a more contrasting surface by blending in larger

Natural objects

fibres or simply pressing material such as small petals into the surface of a sheet of wet pulp. You can make some very unusual papers out of a range of plant fibres such as the leaves of the Iris plant which can be used as an alternative to paper pulp. The cellulose in the leaves needs to be broken down first by soaking the leaves in a solution of caustic soda and then washing the fibres to remove any trace of chemicals. The fibres are then blended and pressed in the same manner as other pulps.

Laminating

Laminating is a process which involves pressing long fibres such as string and netting between two or more layers of wet pulp. This method of constructing paper allows you to experiment with creating some very original shapes. You can either sandwich the string between two layers of paper pulp or use the string or netting as a structure on which to press broken areas of pulp into irregular shapes.

String and coloured threads

Pulp and papers with additives

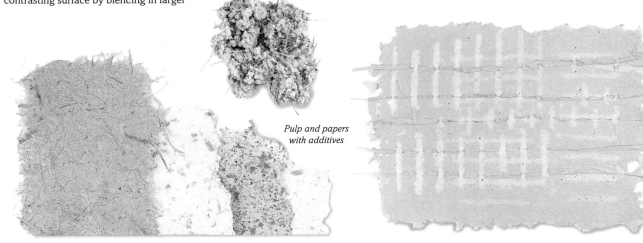

CREATING AN IMAGE IN PAPER

HAVING EXPLORED THE PROCESS of making paper you can now adapt this technique to create your own imagery. The raw pulp can be coloured most effectively by adding dyes but you can also use water-based paint. The different coloured pulp can then be manipulated into shapes to form a composition of varied areas of colour. An excellent way to create an image in your hand-made paper is to use sheets of aluminium mesh (purchased from stores dealing in car accessories) which can be cut into templates and used to create precise shapes of colour.

Hand-made paper overworked with crayons and paints

TO CREATE AN exciting image using hand-made papers you can experiment by overlaying complex arrangements of different coloured and textured pulps and later rework the surface of the dry paper with different materials. The design of your sheet of hand-made paper can be as simple or intricate as you desire. The piece above uses different coloured pulps for the basic shape of the horses and then uses gold pastels and paint to create the highlights and embossed patterns.

Coloured pulps

Red

Sea salt

Yellow

Green

1 ▲ Make yourself some stencils by cutting fine aluminium mesh into your chosen shape. It is important to choose your shapes carefully and to practice some layouts before you start.

2 ▲ Place your chosen colour of base layer on the prepared board. Submerge the stencil in a different coloured pulp and then place the shape on the base layer and lift off in the usual way.

3 ▲ After you have created the basic layout you can then add highlights to the images by simply submerging just small areas of the stencils in contrasting colours of pulp and placing these on top.

4 ▲ You can use any shape of stencil to build up your image and you can add many subtle variations of colour. Leave the pulp to dry in the usual way before applying any other media.

Working on hand-made papers

Working onto hand-made papers is very satisfying as the addition of further colour pigments emphasizes the colour and texture of the paper. You can exploit the texture of the paper surface by using a selection of dry drawing and painting media.

A light application of charcoal or soft pastels will leave a grainy textured area of pigment through which the colour of the paper will sparkle. Oil pastels have a more sticky quality and you can experiment with melting the pastels into the paper using a warm iron on a sheet of paper placed over the art work. It is also worth experimenting with blades, sandpaper and wire wool to scratch through the layers of pigment. An interesting way of removing the colour of the dye in the paper and of any other subsequent application of ink, is to use household bleach to take out the colour and leave a faded white pattern on the surface. You can further work the surface of the paper by tearing and cutting additional pieces of paper and gluing these and other light objects, such as feathers and string, to the surface. Alternatively, you can print patterns on the surface using painted shapes of card and plastic rubbers.

Various hand-made coloured papers

Building up colour

1 ◀ Once finished a piece of patterned hand-made paper can be overworked using a variety of media. In this piece the artist starts by using neat bleach to produce white marks on the paper.

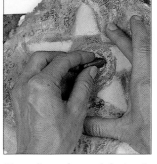

2 ▶ This particular piece has been overworked using soft pastels and crayons of various colours but you can over work your paper with any kind of media you find suitable.

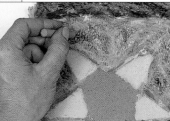

3 ▲ An embossed design is created in the centre of the star by rubbing a metallic pastel over a textured surface. Here the artist has used a patterned wooden board for the rubbing.

Materials

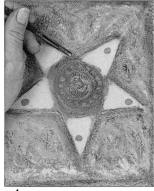

4 ▲ The metallic wax crayon can be overworked and emphasized using gold poster paint or gouache.

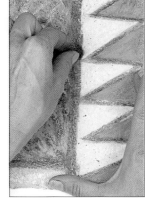

5 ▲ The distressed effect is created by scratching off areas of the crayon and paint with wire wool.

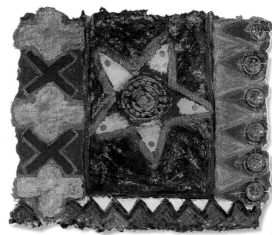

This piece shows the level to which these handmade papers can be overworked using a variety of different techniques.

Wire wool

Gold crayons and paint

Wax crayons

Brush and bleach

COLLAGE-LAMINATE & FROTTAGE

FROTTAGE IS THE TECHNIQUE of taking a rubbing from a textured surface. These rubbings can then be developed into sophisticated designs by collaging the different patterns into a composition. Laminating is an extension of collage and is produced by gluing thin sheets of tissue paper together, which effectively causes the sheets to become transparent layers of colour. These two techniques can be explored and used together.

Strips of frottage

TO CREATE A FROTTAGE the side of a wax crayon or chalk is rubbed evenly across a thin sheet of paper placed over the surface of any textured form. This process can be developed into complex overlayerings of patterns by taking a rubbing of a surface and then using the same sheet to take a rubbing from another surface. There are a multitude of patterns to be found including wall and floor surfaces, grid patterns on metal castings, and the bark of trees. A collection of patterns can be employed as a palette of textures for future collages.

Composing with patterns
You can overlay different patterns of the same or contrasting colours using a wax crayon, oil or water soluble pastel. You can also take a rubbing and then shift the paper to another angle and take another rubbing so that the overlaid rubbing runs in a direction counter to the first impression. Intriguing and dynamic designs can be composed by cutting the frottaged sheets into shapes and placing the different textured areas into a composition, thus capitalizing on the contrasting textures and directions of the marks.

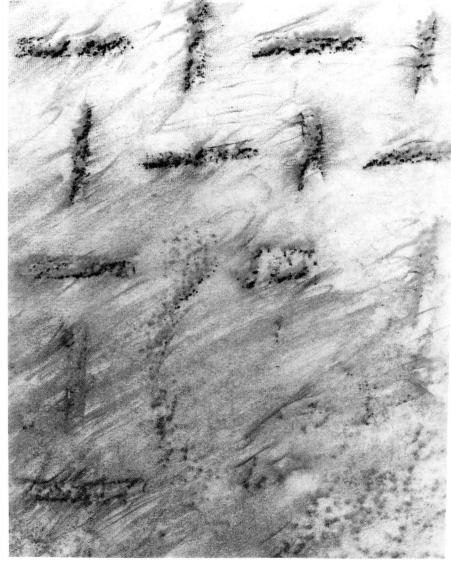

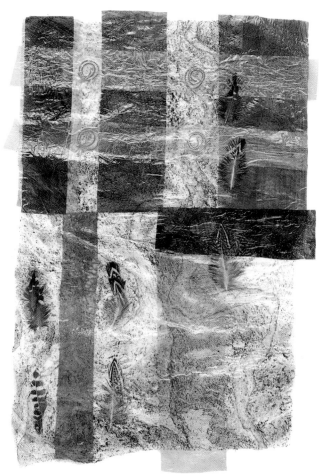

Detailing your work

The artist has contrasted the delicate monochrome rhythms of the frottage by laminating additional bands of a darker tone and coloured string and feathers into the surface of the composition.

Laminating paper step-by-step

1 ▲ Place tissue paper over your chosen textured surface and rub with the side of a wax crayon or pastel to reveal a pattern. You can also use white and metallic crayons on coloured paper.

2 ▲ Place the frottaged tissue over a sheet of plain tissue which has been coated with watered-down PVA glue. Flatten out the paper using a printmaking roller.

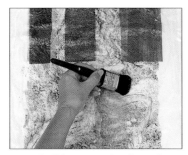

3 ▲ Build up your laminated frottage using different pieces of tissue paper. You can use shop-bought coloured tissue or create your own colours by using washes of thinned-down acrylic paint on top of each glued layer.

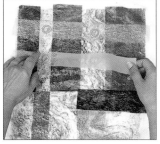

4 ▲ A variety of objects can be added into the laminating process including string (coiled into shapes) and metallic papers. Simply place them onto the paper and paste another sheet on top.

Working onto your lamination

In this composition the artist has created a *tour de force*, exploring the possibilities of combining frottage and lamination. Frottaging has been used to lift a pattern from the weathered surface of a stone, creating a snake-like movement through the composition.

Subsequent sheets of tissue paper have been prepared by staining and bleaching out the colour of the paper using a brush to paint on patterns of bleach, and by printing patterns onto tissue paper using corrugated card. The overlaying sheets of tissue paper have been transformed into transparent veils of colour by the diluted washes of PVA and these contrast with the opaque forms of the feathers and string embedded between the tinted layers of tissue paper. Another way to develop your laminated frottage is to use an oil-based medium for the frottage and overlay a wash of watercolour on top, this will create a striking resist technique.

Creating details

The ochre tissue paper creates a golden glow in contrast with the texture of the stone design and twists of string. Ink from a fresh photocopy can be transferred onto another sheet by placing the photocopy face down, dampening the back with a solution of detergent, water and spirits and then rubbing hard.

Low Reliefs

THE VISUAL QUALITIES required for a good collage are shape, tone, colour and texture. As you start to use materials with a more pronounced texture you will inevitably begin to explore low relief form. You can create these forms out of card, wood and paper. Paper is a highly versatile medium and not immediately associated with low relief, but it can be used to create striking low relief forms by cutting, folding, gluing, and weaving. There is also a diversity of suitable low relief materials provided by objects found in nature and the discarded products of a consumer society.

Fretsaw and wood

Found objects

A LOW RELIEF COLLAGE requires a unifying theme and so simply by using the right natural objects you can produce harmonies of textures and forms. You can see the natural harmony in the common characteristics of weathered fragments such as drift wood, rope, bits of corroded metals and plastics. As well as collecting materials you can develop low relief works in prepared wood, sheets of card, plywood and hard-board which can subsequently be painted and stained to form a coloured low relief composition. Thin wood can be sawn into complex shapes using a fretsaw and glued in place using a glue gun.

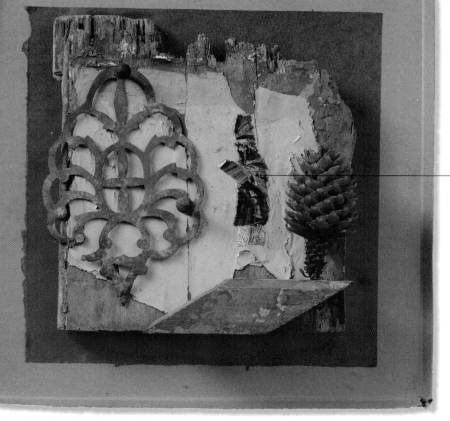

The intense hot colours of the base of the work amplify the enclosed green area, giving this space the impression of verdant coolness and calm. The scale of the paper figure forces the fir cone and the metal cast to be re-read as ornamental bushes. This inventive use of materials epitomizes the creative skill of making a prosaic object appear poetic by allowing the object to evoke other forms by association.

Dick Lee RA, *In a Persian Garden,* **1994, found object collage**

Weaving paper

You can either use a single type of paper or alternate different toned and textured papers as you weave the strips together.

Experimenting with shapes

The artist has created a diversity of low relief forms by experimenting with folding, pleating, curling, crumpling and twisting paper. Another useful technique is to laminate by gluing layers of paper together to create thicker forms that can be carved and cut into in the manner of cardboard.

Tonal collage

A simple means of altering the perception of objects in a low relief collage is to change their natural colour, or to reproduce their form in another material, such as plaster, as seen in the child's hand at the bottom of this composition. By spraying the forms white they have taken on the characteristic qualities of a sculptural arrangement; in the absence of colour the qualities of form and texture are amplified and produce contrasts of light and shadow.

Working in paper

By working with paper you can create complex low relief collages that explore folding, cutting and weaving techniques. The advantage of using paper for construction is the ease with which you can fashion and glue shapes in any position. Initially, you should use neutral toned papers, so that you will be able to see clearly and exploit the tonal play of shadows, created by the folds in the paper.

Fine details

The forms in this composition echo landscape textures and architectural structure. The elements of wind and air are suggested by the two cross shapes which are redolent of the blades of a windmill. In this complex work the artist explores the illusion of space by overlapping the forms to create the sensation of recession.

GALLERY OF COLLAGE

COLLAGE IS AN ESSENTIALLY modern technique. Its unique feature is that it allows artists to explore arrangements of printed materials and found objects as ready-made imagery. By composing these items into harmonious arrangements and unlikely juxtapositions, artists challenge our perception of the familiar and create a new visual language.

In this deliberate pastiche of children's art Dubuffet has combined the complex and natural texture of dried leaves with a quirky use of imagery in the form of a stray donkey. There is no attempt to force the material to look like the subject but rather he a relies on the title prompting an imaginative reading of the materials.

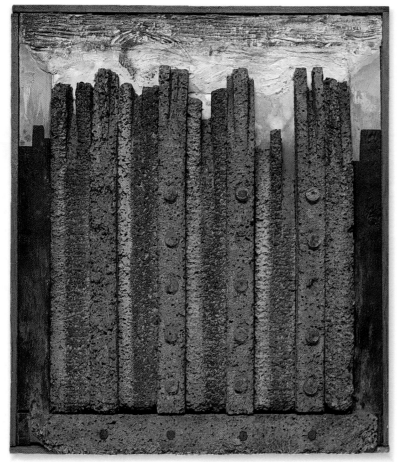

Max Ernst, *Dadaville*, 1924,
painted plaster and cork on canvas,
66 x 56 cm (26 x 22 in)
Max Ernst's (1891–1976) collage work is characterized by the diversity of found materials he utilized. As a soldier in World War One he was radically affected by the absurd waste and destruction he witnessed, and this led to a profound scepticism of the establishment in life and art. In this work Ernst creates an illusion of city structure by juxtaposing and transforming found materials into an arrangement of new meaning.

Jean Dubuffet, *L'âne égaré* 1959,
leaves and bark, *68 x 51 cm (27 x 20 in)*
Jean Dubuffet trained as a painter but is also noted for his unconventional use of materials in the creation of "Art Brut" (raw art) imagery. Dubuffet experimented extensively with creating heavily textured surfaces adding sand to paint and collaging with found materials. He would use textures as diverse as printed images and butterfly wings. The artist deliberately combines contradictory qualities bringing together an aesthetically refined and subtle control of texture.

Peter Blake, CBE RA
Manhattan Boogie Woogie,
1994, photo-collage
32 x 32 cm (12½ x 12½ in)
*Along with David Hockney and
Richard Hamilton, Peter Blake
was a key figure in the Pop Art
movement. His originality lies
in the deliberate use of the
transient imagery of advertising
and mass culture which had
previously been regarded as
outside the bounds of fine art.*

Blake creates a rhythm of
negative shapes, produced
by a deliberate arrangement
of cut shapes, and with the
found imagery.

Anneli Boon,
Untitled, **1994, paper,
photocopies and
emulsion paint**
*45 x 33 cm (18 x 13 in)
Anneli Boon has used photo-
graphs of architectural forms
which have then been reproduced
using a photocopier. The modern
process of photocopying, with
its facilities for enlarging and
reducing the scale of the image
produces a large range of material
for the artist. Here, several copies
of the same image, in different
ratios of scale, have been cut out
and then pasted onto a textured
sheet of paper that has been
distressed by staining and
crumpling the surface.*

BLOCK PRINTMAKING

BLOCK PRINTMAKING IS A TECHNIQUE of relief printing which involves cutting a design into a block. Traditionally wood blocks or lino are used but there are a wide selection of alternative materials which can be carved or cut without using carving chisels. A sharp craft knife can be used to carve printing blocks from thick sheets of card, root vegetables, plastic rubbers, polystyrene and plaster of paris. Where the surface of the block has been cut away the ink will not be absorbed and the area will appear as white in the final printed image.

Basic print shape

Cardboard cut outs to use as printing shapes

THE SIMPLEST way to block print is to cut shapes out of a thick piece of card, paint them with a water-based paint and press the card, paint side down onto a sheet of paper. Making a print using small blocks involves pressing the block onto a pad of printing ink or brushing paint onto the raised surface of the block. The block is then positioned and pressed onto the paper leaving a print of its cut shape. You can create a repeat

Using found prints

Block printing is an excellent technique to use in combination with collage. Here the artist has used a combination of media with a selection of found materials. A sheet of brown paper has been treated with a broken application of white paint to create a surface redolent of a weathered wall. Sections of printed materials including musical manuscripts and images of palmists hands have been incorporated into the printwork.

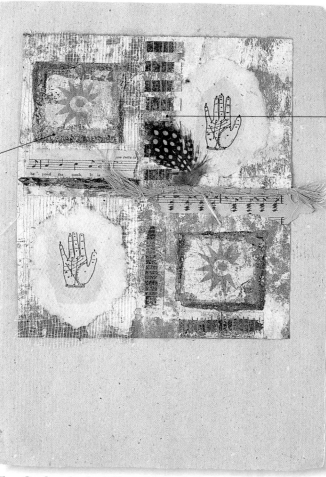

Flea Cooke, *Ancient Signs*, 1993, Collage and prints

A sheet of brown paper was textured with white gouache using a sponge. The artist then collaged sections of a musical score, hand-painted strips of paper, gauze, string, and feathers to contrast with the underlying texture of the paper.

The artist has built up this design in a limited colour range to focus our attention on the rich variety of textures in the work. The gold border has been printed from a rubber eraser which has been cut into the shape of a star. The gold paint has been applied to the handmade block and carefully repeated diagonally across the composition.

Flea Cooke, *The garden*, 1993, block printing and bleach

Dream garden

This composition was developed using broad applications of violet green and yellow ink to evoke the images and colours of a garden. The pattern of parallel lines redolent of garden fencing were produced by bleaching out the ink using a fine brush.

The pressure of the print block squeezes the paint towards the edges of the cut shape and as a result the printed shape will look slightly transparent surrounded by a distinct raised edge of opaque colour.

The isolated location of this single block print (representing a snail) has given the composition a point of focus away from the repetition of shapes in the upper section. The design in the block was created by cutting a spiral line then superimposing a series of lines radiating from the centre of the shape.

print using this method by re-inking and applying the same block several times to create a recurring pattern. In the case of larger block prints the block is inked up using a roller which will apply the ink evenly to the raised surface of the block. A sheet of smooth paper is carefully placed on the inked-up surface and even pressure should then be applied to the surface of the paper to lift an impression onto the paper. Pressure can be applied by using either a roller or by rubbing the convex side of a large wooden spoon across the back of the paper. It is neccessary to stop at intervals whilst rubbing and lift one corner of the paper at a time to check that the rubbing has evenly lifted the ink onto the paper.

EASY-TO-MAKE BLOCKS FOR PRINTING

This selection of small blocks are all carved from plastic erasers. The erasers had a design drawn on in ballpoint pen and the negative shapes were cut away using a craft knife. You can either press the cut block onto a inked printing pad or use a brush to apply paint to the raised areas of the block. Delightful repeat patterns can be created by re-inking and printing the same block across different areas of the artwork.

MONOPRINT

Materials

Clean sheet of glass

Pencil

Turpentine

Masking tape

MONOPRINT IS A SIMPLE and manageable printmaking technique which gives exciting results particularly in the texture of the printed surface. It is so named because it is a method of printing which produces a single print from a smooth sheet of metal, glass or acetate, any of which can be used as the printing plate. The plate can be worked on in a number of ways, by painting and wiping ink into a design or using stencils to create shapes. A monotype print is an ideal base for a mixed media composition as you can overwork the print with pastels or paints.

1 ◀ To ink up the roller squeeze a line of ink from the tube at the top of the plate and roll the ink so that it is evenly distributed over the plate.

2 ▶ Place a sheet of paper onto the plate avoiding movement. Draw a design onto the paper using a pencil. Avoid touching the paper with your hand.

3 ◀ You can create areas of tone by gently pressing your finger onto the back of the paper this will lift ink from the plate onto the paper surface.

4 ▶ Again, being careful not to touch the back of the paper, in contact with the plate, lift the paper from the plate by pulling away from one corner. The print will be a mirror image of the original drawing.

Alternative method

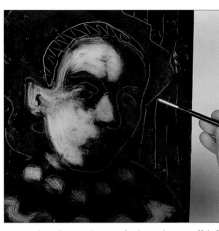

1 ▲ An alternative technique is to roll ink onto the plate and then wipe and scrape lines into the ink to create areas of white.

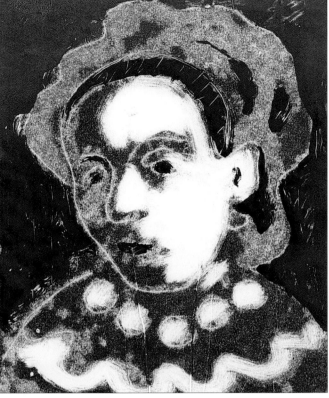

2 ◀ Place a large sheet of paper on the plate, and tape down securely. Use a roller to apply pressure and lift the image from the plate.

3 ▲ In the final print you can see how the details added using a fine brush with diluted ink creates a striking positive and negative tonal image.

Small brush

Rubber roller

Tubes of ink

Any suitable paper

USING STENCILS AND OVERWORKING

Monoprints can be developed into sophisticated images by building up the print using stencils. A shape is drawn onto a sheeet of paper and cut out. The printing plate is then inked up in the normal way and the paper stencil laid on the plate. The stencil masks out areas of the plate and when the printing paper is placed and the impression is lifted off, the stencil shape remains untouched by the ink. By using different shaped stencils a complex design of superimposed shapes can be built up into a multilayered print. Monoprints are also ideal bases for overworking in pastel or paint to create a more complex piece of art.

1 *The plate was inked up and two stencils were applied to the plate. One for the silhouette of the figure and one for the shape of the face. Lines were then scribed into areas of ink to add detail and a print lifted.*

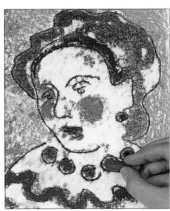

2 *The finished print can be worked on in a range of mixed media. You can overwork the print with soft pastel to add colour or even watercolour which will be resisted by the oil-based ink.*

COLLAGRAPH PRINTING

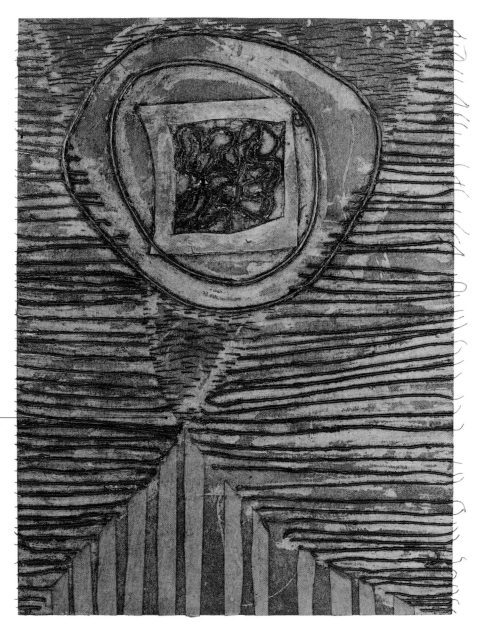

COLLAGRAPH IS A PRINTING TECHNIQUE which involves building up, rather than cutting away, a low relief surface. The name collagraph is a derivative of collage, as it is basically a form of collaging materials to create a print. A low relief design is created by gluing materials to the surface of a stiff sheet of card. An enormous variety of textured materials can be used, from coarse cloth, sand, and string to grasses and pulses. The textured collagraph produces a print with an embossed surface which mirrors the low relief surface of the original collagraph.

String

Collagraphs can be displayed as works of art in their own right.

Basic collagraph
In this collagraph a sheet of stiff card has been used as a base for an interesting diversity of low relief textures. A pattern has been created by gluing string to the surface to form a linear design. Using a craft knife a pattern of marks has been scored into the card and other shapes cut from paper to create contrasting areas of texture. A collagraph can also be constructed purely from PVA glue by dribbling the glue across the card or by laying down a thick area of glue and drawing into the wet surface to create negative lines.

In this composition a linear design has been created by using string and additional textures have been produced by cutting into the card. A unique feature of collagraph printing is that the collagraph itself acquires a subtle beauty as it is constantly inked, wiped and re-inked in different colours. Many are infact kept and framed as low relief works.

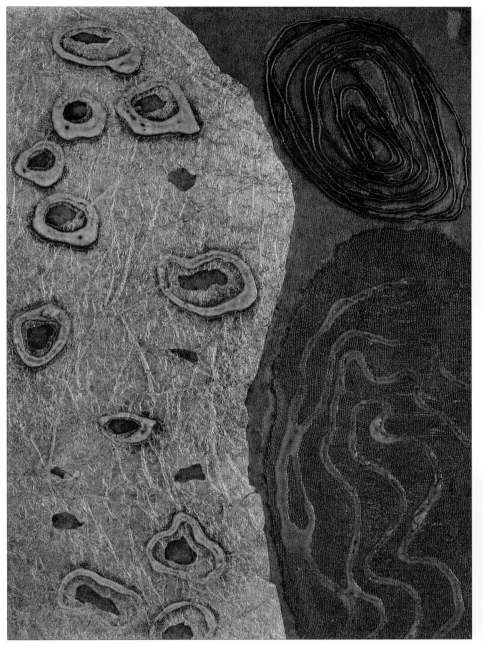

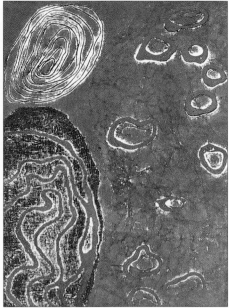

Monotone print

In this first print taken from the original collagraph (see left) there is a surprisingly different appearance. The artist used a roller to ink-up the collagraph in a single dark blue colour and the raised surface of the materials has created a striking white halo around the textured forms in the print.

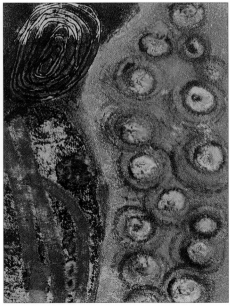

YOU CAN USE many materials to build up a collagraph including wallpaper, fine and coarse cloths, netting and light metals such as tin foil. When the design is finished the surface should be sealed with PVA glue or shellac. After the surface has dried the collagraph is inked up using a roller or a brush. A sheet of paper is laid face down on the print and the back of the paper rubbed in the same manner as block printing. If you dampen the surface of the paper it will more readily accept the ink.

Original collagraph

Anneli Boon is a Finnish artist who has explored the patterns in the strata of weathered rock formations as a source for her collagraph compositions. She has created this collagraph using a combination of fine gauze, a sheet of foil, string and dribbled glue. The design was painted over in a coat of shellac to seal the surface, allowed to dry and inked using a roller. A sheet of paper was laid on the print, held in place with masking tape and the back of the paper rubbed to lift an impression from the collagraph.

Multicoloured print

In this second impression from the same collagraph the composition is radically altered by the application of different colours. The artist has carefully painted different colours on various parts of the print to create two contrasting halves to the composition and to amplify the circular forms.

GALLERY OF MONOPRINT

THE SIMPLE TECHNIQUE of monoprint has been used by these artists to create a remarkably diverse range of visual imagery; from monochrome prints that have the quality of a tonal drawing to complex multilayered colour compositions. Printmaking is normally associated with multiple editions of the same image, however, monoprint, as the name implies, involves building up a single print surface and in this sense is closer to the process of creating a painting. Monoprints can be produced as either a painting on a plate that is transferred to paper by printing, or by using a roller to impart a uniform texture onto the printed image. Artists who work in monoprint frequently overwork the print using paints or pastels.

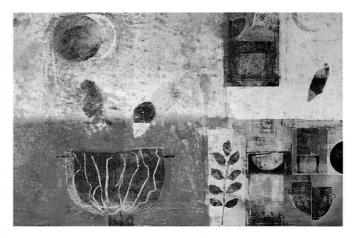

Tom Wood, *Monoprint II,* 1991, monoprint
106.5 x 160.5 cm (42 x 63½ in)
Tom Wood has developed a complex surface of overlaid colours in a monoprint based on a still life. The surface of the print has been built up through multiple layers of coloured ink using cut paper stencils to mask out areas of the plate to create the shapes within the composition.

The artist has cut leaf shapes out of paper and laid them onto the printed surface of the paper. Where these stencil shapes have been applied to the print the subsequent application of white ink has been masked from the paper. The stencil was then pulled away from the paper revealing the colour and texture of the previous layer of ink.

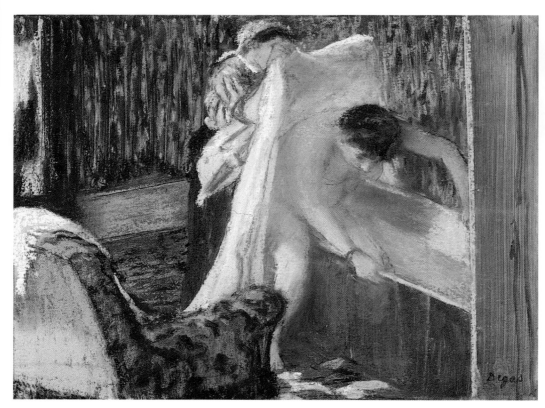

Edgar Degas, *Woman Leaving Her Bath,* 1876–77, monotype and pastel
16 x 21.5 cm (6¼ x 8½ in)
Degas was a master draughtsman who obsessively explored the theme of the body in movement. He was a main protagonist in the development of monoprint. Here the image has been developed by brushing and wiping black ink onto a plate and this can be seen in the grey areas of the wall. The print was overworked in pastel to add colour and more texture.

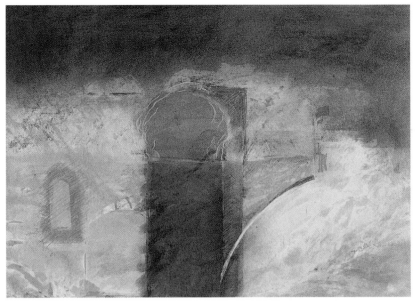

Bob Baggaley, *Avebury Rd,* **1993, monotype**
40.5 x 51 cm (16 x 20 in)
Bob Baggaley combines different print processes to create
monoprints based on a landscape theme. An image is
printed using either silkscreen or lithography and individual
prints are then overworked using a monoprint process.
The artist has experimented with the surface by using
a thinner to dissolve the surface of the ink and to reveal
the previous layers of colour.

Bill Jacklin RA, *Untitled,* **1993, monotype**
101.5 x 121.5 cm (40 x 48 in)
In this energetic monoprint of figures bathing the artist has
used the pronounced texture of sweeping brushstrokes in blue
and green ink to evoke the motion of the waves and then
dropped thinner onto the plate in spots to displace the ink
and create the effect of foam. A small brush has been
used for the fine details of the figures in motion.

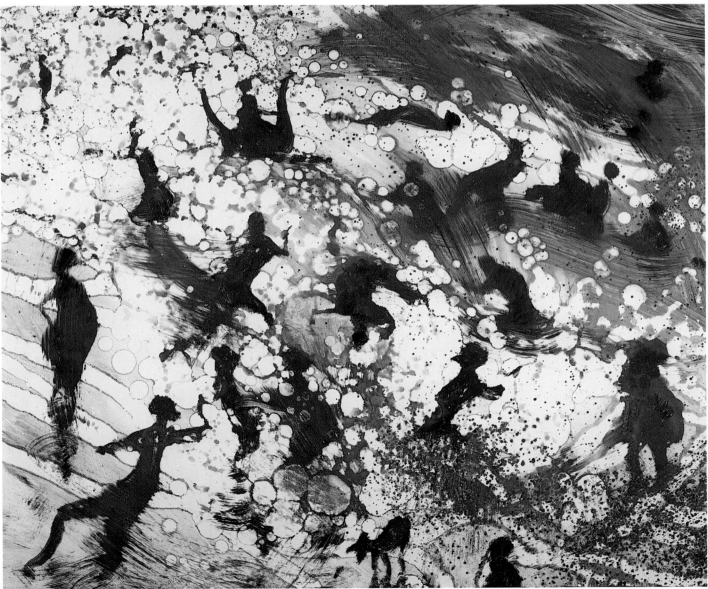

PRESERVING AND STORING

PRESERVING AND STORING finished works requires careful consideration since mixed media surfaces are easily spoiled by careless handling. Framing under glass is the best solution for preserving low relief work because this isolates the artwork's surface from air pollution. Works can also be stored in a portfolio with a covering sheet of tissue paper.

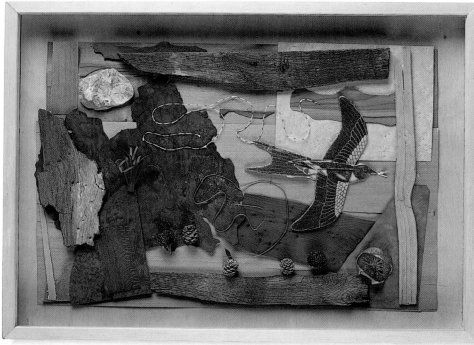

Box frame
In this assemblage the box frame has been specifically designed to allow for adequate clearance of the low relief forms under the glass and to allow the irregular format of the composition to be seen clearly without compromising the three-dimensional effect of the collage.

THE BEST METHOD FOR preserving your work depends on the size of the piece and the nature of the materials used in the composition. As a general rule it is recommended that oil and acrylic based paintings are given a coat of picture varnish to preserve the surface of the work from airborne pollution. This is sufficient protection as it is expensive to frame large works under glass.

You can store works on canvas and board by wrapping them in polythene or in bubble wrap when transporting the work. Encaustic painting, heavily textured and low relief surfaces along with collage and works on paper will absorb dust and moisture from the atmosphere. As these surfaces are not recommended for varnishing they are best framed under glass.

Cross section of the box frame
In this cross section view of the box frame you can see that this design of frame is deep enough to allow adequate clearance for the low relief forms in the composition.

Corner view
A box frame differs from other frames because the glass and the base are held apart by slotting into recesses which are cut into the inner edge of the moulding.

Framing under glass

There are many different frames and the best way to choose a suitable one is to visit a contemporary gallery or a professional picture framer to see the various types available.

Some wooden frames have moulding which is stained or coated in gesso or gilt to form a more elaborate surface. Aluminium frames can also be purchased in kits for which you will need to have glass cut to size from a glazier. Framing makes a tremendous impact on the appearance of a work and will greatly enhance its presence and value. Choose a frame which allows for a border of at least 5-7 cm (2-3 in) around a work and test the colour of the frame against the artwork so that you can see if the colour goes with the composition.

Works on paper are mounted on card with a window mount placed on top. If you choose this method of framing it is essential that the colour of the mount works with the key colours of the composition.

Hand-made frame
In this inventive frame offcuts from a woodmill have been used to create a frame with the particularly original feature of string to link the corners.

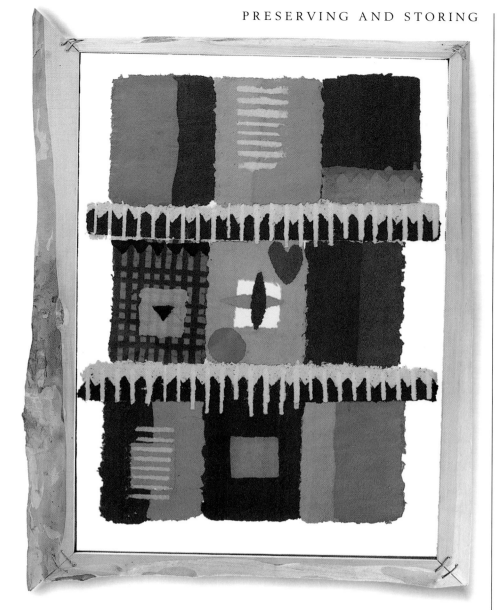

FIXING AND STORING

1 *Dry media are easily spoilt and need to be preserved by a light spray of fixative to fix the pigment to the support. It is vital not to overspray the surface as this can darken or displace the pigment.*

2 *When storing work the most important thing is to cover the surface and to avoid friction which displaces the surface pigment. Make a cover by taping a sheet of tissue, greaseproof or tracing paper to a piece of card and place the artwork underneath.*

GLOSSARY

ACRYLIC PAINTS These are bound by an acrylic and are water-soluble but unlike watercolour and gouache they dry to an insoluble plastic film. Acrylic is ideal for creating surface texture in a painting as it can be worked in thick impasto or with added texturing. Manufacturers have developed a range of additives which can be added to alter the texture of the paint or to retard the drying time to allow for more controlled blending of colours.

ART BOARD Artists' quality paper mounted on card. It gives the support a stiffness which reduces the incidences of pastel loss caused by the flexing of the paper surface.

ARTISTS' QUALITY PAPER Paper with a neutral pH balance and a high rag content which does not yellow and become brittle with age.

ARTISTS' QUALITY PAINT These paints are labelled with information on the nature of the pigment and indicate the lightfastness of the colour.

BLENDING A technique used in the manipulation of dry drawing and painting media such as charcoal, chalks and pastels. Using either a finger, brush, tissue or cloth colours can be worked into each other on the support to achieve smooth gradations of tone.

BLOCK PRINTING A technique of relief printing which involves cutting a design into a block. Traditionally wood blocks or lino are used but there are a wide selection of other materials such as thick sheets of card, root vegetables, plastic rubbers, polystyrene and plaster of Paris which can be carved or cut using either wood carving

chisels or a sharp craft knife. The surface of the block is inked and a print taken by applying pressure to the back of a sheet of paper placed on the inked block. Where the surface of the block is cut away these areas appear as negative white lines or shapes in the printed image.

CANVAS There are two main types of canvas: artist's linen, made from flax, and cotton duck. You can purchase pre-primed canvases on various sized stretchers or prepare your own.

CHARCOAL Carbonized wood made by charring willow, vine or other twigs in air tight containers.

COLLAGRAPH PRINT Collagraph is a printing technique which involves building up a low relief surface using light materials which are arranged and glued onto a stiff sheet of card in the manner of a collage. The raised surface is inked and a print taken by applying pressure to the back of a sheet of paper placed on the inked surface. Collagraph prints have a characteristically embossed surface which mirrors the low relief forms of the original materials.

DAMMAR A soft resin, soluble in turpentine and used to make a gloss varnish. You can make an acceptable varnish by dissolving some dammar resin in a jar of turpentine or white spirit.

DIFFUSER A spray diffuser is a tool for spraying either a liquid pigment or fixative in atomized droplets onto the surface of a support. Two small metal tubes are hinged and opened at right angles to each other. The end of the longer tube is immersed in the medium and holding the shorter end with the plastic mouth piece between your lips, blow firmly, and the action of your breath will draw the fluid up the longer tube and atomize the liquid into a fine spray. You can vary the density of the spray according to the pressure of your breath and the distance you hold the diffuser from the support.

FIXATIVE A resin dissolved in spirits which is sprayed onto a charcoal or pastel work to fix the particles of the medium to the support. Fixative is also used between layers of dry drawing and painting media to stop the previous layer blending with the next application of colour. Fixative should be used sparingly as a heavy application will alter the appearance of the work.

FROTTAGE A technique of taking a rubbing from a textured surface. A sheet of thin paper is placed onto the textured surface and using the side or blunt end of either a stick of charcoal, crayon or graphite stick the chosen medium is rubbed vigorously over the back of the paper. The crayon will only impart pigment to the paper where the raised areas of the textured surface are in contact with the paper.

GESSO A primer manufactured for creating low relief and textured supports.

Pastels

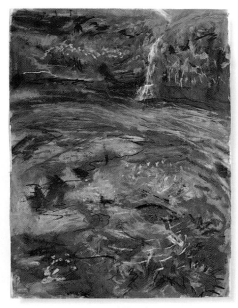

Waterfall study

Bleach and ink

IMPASTO A dense application of paint which forms a low relief surface.

INKS The main types of ink are water-based and shelac based inks. Shelac inks are water proof when dry and are suitable for overpainting.

LAMINATING An extension of collage and is a process of gluing thin sheets of tissue paper over each other between layers of PVA glue. The glue transforms the tissue paper into transparent sheets of colour.

MASKING FLUID This is a latex liquid which can be applied with a brush or dip pen to mask out areas of an artwork before applying another wash.

MASKING OUT A technique of covering areas of the support using either masking tape or a sheet of paper to block a subsequent application of medium. After applying the medium the masking tape or sheet is removed to reveal the previous tone of the support which shows through the application of medium.

MONOPRINT A printing technique which results in a single print.

MONOTYPE A form of monoprint which involves applying ink to a plate in a design and taking a print. The process of inking up the plate can be repeated and applied to the same paper so that an image is built up in layers. Stencils cut from paper can be used to mask out areas and create shapes in the design of the print.

OIL PAINT Paint bound by poppy or linseed oil. The most popular medium for easle painting because of its ease of manipulation and saturated colours. With the addition of resin such as dammar varnish or gel medium it is possible to glaze washes of colour in oil paint.

OIL PASTEL Pastel bound by oil as opposed to gum. The oil gives it a slight transparency and a strong adherence to the support. There are less colours available than in soft pastels.

OPTICAL MIX This occurs when small areas of colours next to each other appear, to the eye at a certain distance, to merge and become a third colour – red and yellow dots will mix and become orange.

PUTTY RUBBERS These are suitable for erasing a range of dry drawing media such as pencil, charcoal, chalk and pastel. The particular quality of the putty rubber is that the mediums' particles adhere to the putty and are lifted from the fibres of the paper when it is pressed against the surface of a drawing. Putty rubbers can be kneaded into a fine point for detailed work, where you can effectively use this type of rubber as a drawing tool, creating highlights in a work as you remove the pigment and reveal the surface below.

PVA Poly vinyl acetate is a glue medium used for gluing paper and binding pigments to the surface of the support.

S'GRAFFITO The technique of scratching lines in a surface application of colour using a blunted knife. The lines reveal the original surface colour of the support which contrasts with the application of the overlaid colour.

SCUMBLING A technique of layering colours by means of a light application of the side of a pastel which allows some of the support or previous application of pastel to show through the new application of colour.

SOFT PASTELS The original form of pastel manufactured in the widest range of up to three hundred colours and tints. Pigments are mixed with a light solution of gum

tragacanth and precipitated chalk to create the tints of colours. The weak solution of gum ensures a very soft texture making this form of pastel most suitable for painting techniques.

STIPPLING The technique of applying colours in small points using a stabbing and dotting application of the tip of a pastel.

SUPPORT The surface you choose, i.e. paper, board or canvas.

TOOTH OF PAPER Paper when examined under a microscope appears as a felted weave of fibres and trap particles of colour from a dry medium. The coarser the texture of the paper the more tooth and more medium is retained by the paper surface.

Brushes

WAX ENCAUSTIC A painting medium made by mixing powdered pigments into melted beeswax. The advantage of wax is that it is a very stable colouring medium as it does not darken with age in the manner of oil paint. It is more complicated to use because to keep the medium in a liquid state, the pigment is manipulated using heat. An alternative is to thin the melted wax to a maleable paste by adding turpentine. When it sets this medium is mixed with oil paint.

Scalpel blades

Pastel frottage

A NOTE ON TOXICITY

• When using and combining a wide selection of materials it is important to be aware of the health hazards.

All art materials are required by law to label clearly there chemical contents and levels of toxicity. You should avoid inhaling the dust from powder pigments and fumes from thinners, glues and fixative sprays. It is also important to be aware that pigments and thinners can be absorbed through the skin and so prolonged contact should be avoided. Always keep the lids of solvent jars screwed on tight and only use as much as you need at any one time. Artists should also make sure they avoid licking brushes with paint on them. If you are in any doubt about the toxicity of a product refer to the manufacturer directly.

INDEX

A

acrylic paints, 16-17, 70
 experimenting with surfaces, 32
 multilayered compositions, 28, 29
 textured, 35
adhesives *see* glue
aluminium mesh, 52
art board, 12, 70
artists' quality paint, 17, 70
artists' quality paper, 70

B

beeswax, 36
Blake, Peter, 59
Blake, William, 9
bleeding, 18, 22, 23
blending, 70
block printmaking, 60-1, 70
boards, 12, 13
box frames, 68
Braque, Georges, 10
brushes, 16, 44
bubble wrap, 25, 45

C

canvas, 12, 70
charcoal, 6, 15, 70
 and black ink, 18-19
 coloured pencils, 14
 fixatives, 15
 and pastels, 20-1
 pencils, 15
 and watercolour washes, 22
Chinese brushes, 15, 19
Chinese ink, 15, 19
Clatworthy, Robert, 21
cling film, 25, 45
Coker, Peter, 27
collage, 6, 7
 colour collage, 46-7
 gallery, 58-9
 history, 10
 laminating, 54-5
 low reliefs, 56-7
 materials, 42-3
 photo-collaging, 42, 48
 texture, 35

and wax encaustic, 37
collagraphs, 45, 64-5, 70
colour:
 dyeing paper pulp, 52
 line and, 22-3
 optical mix, 71
coloured charcoal pencils, 14
Conté sticks, 15

D

Dada, 10
dammar, 70
Degas, Edgar, 9, 66
diffusers, 19, 70
Draper, Ken, 30-1, 41
drawing:
 gallery, 26-7
 materials, 14-15
Dubuffet, Jean, 58
dyeing paper pulp, 52

E

erasers:
 block printmaking, 61
 putty rubbers, 14, 71
Ernst, Max, 10, 58

F

fabrics, collage, 42
felt tip pens, 14
fixatives, 15, 69, 70
foil, 25, 45
found objects, 43, 45, 56
framing, 68-9
fretsaws, 43
frottage, 18, 54-5, 70

G

gel medium, 33
gesso, 8, 70
 with additives, 13
 textured, 35
 and wax, 36-7
glue:
 adding texture, 34
 collage, 43
 collagraph printing, 64-5
 multilayered compositions, 28
gold leaf, 8

gouache, 16
 impasto, 32
multilayered compositions, 28-9

H

history, 8-11

I

icons, 8
illuminated manuscripts, 8
impasto, 71
 acrylic paints, 33
 gouache, 32
inks, 15, 71
 block printmaking, 60-1
 charcoal and, 18-19
 monoprints, 62-3
 printing, 44
 and watercolour washes, 22

J

Jacklin, Bill, 67
Jones, David, 27

K

Klee, Paul, 11
Klimt, Gustav, 9

L

laminating:
 collage, 54-5
 paper, 51, 71
Lawson, Sonia, 35
Lee, Dick, 56
Leonardo da Vinci, 8
line and colour, 22-3
linseed oil, 35, 45
low reliefs:
 collage, 56-7
 collagraph printing, 64-5

M

Masaccio, 8
masking fluid, 24, 25, 71
masking out, 44, 71
masking tape, 44
materials, 14-17
metals, 39
Miró, Joan, 10, 40

monoprints, 44, 62-3, 71
 gallery, 66-7
monotypes, 7, 45, 71
Moore, Henry, 24, 26
multilayered compositions, 28-9

N

natural found objects, 43, 56
negative space, 47
newspaper, collage, 42
Nicholson, Ben, 27, 40

O

oil bars, 16
oil-based media, 13, 16
oil paints, 17, 71
oil pastels, 17, 71
 resist techniques, 24
 with soft pastels, 30-1
optical mix, 71

P

painting materials, 16-17
palette knives, 16
palettes, 16
"palimpsests", 40
Palmer, Samuel, 9
paper:
 collage, 42
 creating an image in, 52-3
 hand-made, 50-1, 53
 low reliefs, 56
 supports, 12, 13
 textures, 34
 tooth, 71
 weaving, 57
pastels, 6, 8
 and charcoal, 20-1
 fixatives, 15
 multilayered compositions, 29
 oil, 17, 24, 30-1, 71
 soft pastels, 15, 30-1, 71
pen and ink, 15
 charcoal and, 18-19
pencils, water-soluble, 14
photo-collaging, 42, 48-9
photocopiers, 49, 59

Picasso, Pablo, 10-11
Piper, John, 32-3
preserving works, 68-9
primed boards, 13
printed material, collage, 42, 48
printing:
 block printmaking, 60-1, 70
 collagraph, 64-5, 70
 materials, 44-5
 monoprints, 62-3, 66-7, 71
 monotype, 7, 45, 71
putty rubbers, 14, 71
PVA glue, 28, 34
 adding texture, 34
 collage, 43
 collagraph printing, 64-5
 multilayered compositions, 28

R

Rauschenberg, Robert, 11
relief printmaking, 44, 60
reliefs, low, 56-7
resist techniques, 6, 15, 17, 24-5
Rodin, August, 9
rollers, 17, 33
rubbers, putty, 14, 71
rubbings, frottage, 54-5

S

sand, 35
sandpaper, 13
sanguine, 8
Schiele, Egon, 9, 26
scrapers, 16
scumbling, 23, 71
sepia ink, 22, 23
s'graffito, 41, 71
shellac, 45
slate, 39
soft pastels, 15, 30-1, 71
sponges, 17
spray diffusers, 19, 70
stencils, monoprints, 63
stippling, 71
storage, 68-9
supports, 8, 12-13, 71
 texture, 34

surfaces, experimenting with, 32-3
Surrealism, 10, 40
Sutherland, Graham, 28

T

tea bags, 38
texture, 34-5
 collagraph printing, 64-5
 frottage, 54
 gesso, 13
 hand-made paper, 51, 53
 low reliefs, 56-7
 printing, 45
 tin snips, 43
tissue paper:
 laminating, 54-5
 texture, 34, 37
tooth of paper, 71
tortillons, 17
Turner, J.M.W., 9
turpentine, 36, 45

U

unusual materials, 38-9

V

Van Gogh, Vincent, 9
varnish, 68

W

water-based media, 13, 16
 multilayered compositions, 28-9
water-soluble pencils, 14
watercolour, 6, 16, 17
 experimenting with surfaces, 32
 techniques, 23
 washes, 22
 wax resist, 24-5
wax, 39
wax crayons, 15, 54
wax encaustic, 36-7, 71
wax resist, 6, 15, 24-5
weaving paper, 57
wet-into-wet, 23, 33
wet-on-dry, 28
Wood, Tom, 66
wood supports, 12

ACKNOWLEDGEMENTS

Author's acknowledgements

I am particularly grateful for the pleasure of working with the co-creators of this book and sincerely thank Project Editor, Joanna Warwick, Designer, Tassy King and the photographer, Steve Gorton for their professional and creative contributions, and especially for their good humoured company and inventive wit. I would also like to thank the staff and students of the School of Art and Design from the University of Hertfordshire who have contributed many of the works illustrated within the pages of this book. Dorling Kindersley would also like to thank Emma Wirgman, Sam Sutcliffe and Hilary Bird.